IMAGES
of America

PITTSBURG

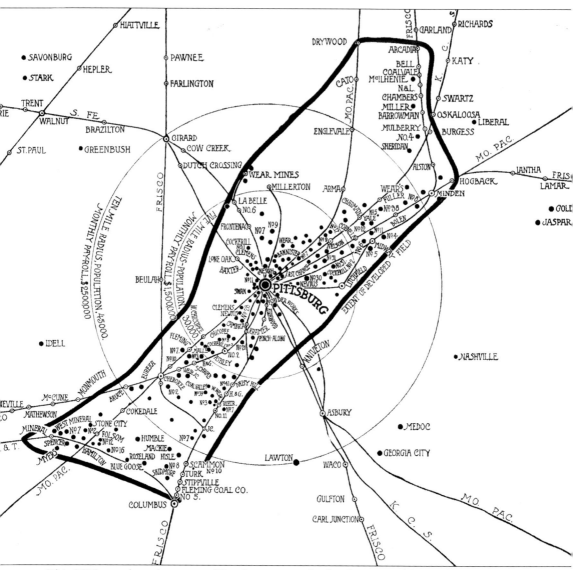

This 1905 map shows how central Pittsburg was to the development of the coalfields in southeast Kansas. Five railroads connected the city to the nearby coal camps and to the nation. Tens of thousands of immigrants from around the world arrived in Pittsburg by railroad to work in the coal mines, zinc smelters, clay industries, and other concerns that developed. Hundreds of millions of tons of coal, zinc spelter, bricks, clay tile, and other products were shipped out of Pittsburg on these same railroads. (Courtesy of Pittsburg State University, Leonard H. Axe Library.)

On the cover: Spectators line both sides of Broadway near Fifth Street to watch a World War I parade in 1917. (Courtesy of Pittsburg State University, Leonard H. Axe Library.)

IMAGES
of America

PITTSBURG

Randy Roberts and Janette Mauk

ARCADIA
PUBLISHING

Published by Arcadia Publishing
Charleston, South Carolina

Printed in the United States of America

Library of Congress Catalog Card Number: 2008935437

For all general information contact Arcadia Publishing at:
Telephone 843-853-2070
Fax 843-853-0044
E-mail sales@arcadiapublishing.com
For customer service and orders:
Toll-Free 1-888-313-2665

Visit us on the Internet at www.arcadiapublishing.com

*This work is dedicated to the memory of the ethnic immigrants
who gave Pittsburg a distinctive heritage as part of the "Little
Balkans of Kansas" and to the many photographers and
historians of Pittsburg whose legacies made this book possible.*

CONTENTS

ACKNOWLEDGMENTS

Unless otherwise indicated, all images are courtesy of the Leonard H. Axe Library at Pittsburg State University. The Crawford County Historical Museum loaned a number of images to the project, and the authors wish to thank Denzel Davidson for his generous encouragement and assistance on behalf of the museum. Pat Clement from the Pittsburg Public Library graciously gave permission to use a photograph from the Don Gutteridge Collection. Finally, we wish to acknowledge the assistance of local historians Brenda and Robert Mishmash, educators Linda and J. T. Knoll, author and professor emeritus William Powell, and photographer Malcolm Turner for access to photographs from their personal collections.

INTRODUCTION

In the winter of 1901, a reporter for the *Pittsburg Daily Headlight* found an elderly man living in an old house on the west edge of Pittsburg near Cow Creek. The old man claimed the distinction of having dug the first coal inside what became the Pittsburg city limits. His name was William Core, and he lived in the area for 35 years. Core was stationed at Fort Scott when the Civil War ended. He was one of the first veterans to push south into what had been the Osage and Cherokee Neutral Lands of Kansas since 1824. In the fall of 1866, Core settled on what later became the Granby tract of Pittsburg, about where the Pittsburg Vitrified Brick Company was established. Core told the reporter that some 10 years before the city of Pittsburg was established, he dug coal out of a vein three feet thick that was cropping out of a ravine near his cabin. Core hauled the coal by wagon to Fort Scott where he found a good market for it. Pittsburg resident A. J. Georgia and other early settlers gave credence to Core's story. They remembered that coal was dug from these outcroppings as early as 1867 and hauled to Carthage, Missouri, for blacksmithing purposes. In 1870, William Core moved to Missouri and did not return for many years. When he did return, Pittsburg was already an important industrial town in Kansas.

History is clear that settlers in Cherokee County began mining coal in the fall of 1866, and the shipment of coal from southeast Kansas began as soon as the Kansas City, Fort Scott and Memphis Railroad reached Fort Scott in 1870. The significant development of coal mining in southeast Kansas, however, did not begin until 1876. Franklin Playter, a 24-year-old Canadian, established himself in Girard, the county seat town of Crawford County, as a farmer, teacher, lawyer, and banker. In early 1876, Playter was approached at his home in Girard by two lead and zinc entrepreneurs from Joplin, Missouri, John B. Sergeant and E. R. Moffett. They wanted Playter to assist them in building a railroad from the lead and zinc mines in Missouri to the railhead at Cherokee. Playter knew as much as anyone about the rich coal seam under southeast Kansas, and he agreed to build the road provided it went directly from Girard to Joplin through the heart of the Cherokee-Crawford coalfield. The site that is now Pittsburg was located on the new Joplin-Girard Railroad, virtually in the center of the coalfield.

Playter, Sergeant, Moffett, and a surveyor named Edwin H. Brown platted the town of New Pittsburg on their railroad on May 20, 1876. Each man took one quarter of the new town, agreeing to erect a building on the corners of what is today the intersection of Fourth Street and Broadway. The agreement was not taken very seriously, except by Playter and Sergeant. Playter erected a frame building on the southwest corner. His brother-in-law W. G. Seabury opened a general store in the building. Sergeant put up a frame building on the northeast corner for George E. Richey, who opened a drugstore. The Sergeant building and lot were purchased in

1877 by John R. Lindburg, who later moved the original building away and built a substantial brick edifice in its place for his own drugstore. At least one corner of Fourth Street and Broadway has been continuously occupied by drugstores to the present day. Pittsburg was incorporated with the status of a third-class city in June 1880, when the population reached 624. In June 1881, the U.S. Postal Service recognized that the older village of Pittsburg in Mitchell County changed its name to Tipton, and *New* was dropped from the name of the thriving Pittsburg in Crawford County. By 1890, the population of Pittsburg increased more than tenfold to 6,697, and it gained the designation of a city of the first class on September 12, 1905.

To mine the coal on a large scale in such a sparsely populated region, in the beginning imported laborers were necessary. Sargent and Playter began a concerted effort to attract coal miners from other coal-producing areas of the United States and from the coal-producing nations of Europe. Broadsides were distributed in coalfields around the world, promising prosperity in southeast Kansas. Steamship companies were hired to send agents throughout Europe to enlist workers by underwriting a one-way passage across the Atlantic Ocean and overland to Kansas. During the four decades after 1876, a throng of immigrants came to the Kansas coalfields. Over 50 different nationalities, including French, Italian, Irish, English, Belgian, German, Austrian, and Slovenian citizens, were documented residents of southeast Kansas before 1920. The diversity of this ethnic mix was unusual in Kansas, and it set Pittsburg and the southeast region apart from the rest of the state.

The original aim of entrepreneurs Sargent and Moffett was to provide railroad access to their extensive lead and zinc holdings in southwest Missouri. Up to 1876, lead and zinc ores typically were shipped to Wisconsin or Pennsylvania for smelting. The opening of the nearby coalfields in southeast Kansas brought about another opportunity. Zinc ores processed in coal-fired kilns required approximately three railroad car loads of coal be burned for every car of ore that was processed. Playter and his investors believed they could establish a viable smelter industry in Pittsburg. They actively recruited smeltermen from Wisconsin, most notably the Lanyon family in 1878, and quickly established 12 smelter complexes in the area at a time when there were only 25 in the entire United States. By 1885, Pittsburg had 48 kilns operating within the city limits. Crawford County was the leading United States producer of zinc spelter and was second in the world, following only the nation of Belgium.

Speculators from across the region and the nation began investing heavily in the mineral and industrial resources of southeast Kansas and Pittsburg. Arthur E. Stilwell of Kansas City, for example, extended his Kansas City, Fort Scott and Memphis Railroad through Pittsburg. Then in 1889, he helped to finance the construction of one of the most modern hotels west of Chicago. The historic Hotel Stilwell remains one of Pittsburg's downtown landmarks. It was in the Hotel Stilwell that Jay Gould and other well-known industrialists stayed when visiting their mining and railroad interests in southeast Kansas. To build the hotel, a new brick factory was established in Pittsburg by William C. Green of Wichita. Smaller brick concerns that met local building needs were established earlier in 1880, but Green's extensive enterprise proved that the clay beds under Pittsburg were of excellent quality. Other manufacturers came from Leavenworth and Atchison and Cincinnati, Ohio, to establish additional brick factories and clay tile works.

In a few short years, Pittsburg had iron foundries, lead and zinc sheet mills, and numerous other manufacturing concerns. It became the industrial center of Kansas and was on its way to becoming the state's fourth-largest city. Pittsburg's factories belched fire and smoke 24 hours a day, seven days a week. The industrial development led the editors of the *Pittsburg Daily Tribune* in 1896 to refer proudly to Pittsburg as "the Smoky City of Kansas." Pittsburg was only 25 years old in 1901, but already it was a mining, manufacturing, and railroad center with a population of more than 15,000. Pittsburg became the metropolis of Crawford County and for much of southeast Kansas. For every year that passed, it seemed that Pittsburg showed substantial gains in wealth, population, and industrial influence. Largely a result of the coal mining, villages and towns ranging in population from 200 to 3,000 grew up all around Pittsburg and acted as additional economic stimulators. The trading population of the city in 1900 was estimated to

be 40,000. The mines gradually employed more men and produced more coal until Crawford County, by 1900, was home to more than 10,500 miners who produced over 4.2 million tons of mined coal. That was 55 percent of the state's entire production. In September 1901, the *Kansas Commercial News* proclaimed Pittsburg was "the Great Black Diamond City of Kansas" and that its coal reserves were "good for a thousand years of prosperity."

Five of the nation's most prominent railroads served Pittsburg by 1901, hauling away its coal and manufactured products and bringing raw materials and merchandise into the city. Lines of the St. Louis-San Francisco Railway; the Missouri Pacific Railroad; the Kansas City, Fort Scott and Memphis Railroad; the Kansas City Southern Railway; and the Atchison, Topeka and Santa Fe Railway all made their way into Pittsburg. Each of the five railroads had a depot, resident employees, and miles of local track, but the most prominent was the Kansas City Southern. It established its shops and division headquarters in Pittsburg and provided employment for 350 to 400 men.

The most important manufacturing plants of the city after 1900 shifted from the zinc smelters to the clay industries. Brick plants and sewer pipe plants made extensive use of the high-quality shale clay beds found in Pittsburg and the immediate area. The Pittsburg Vitrified Paving Brick Company, established in 1890, became one of the largest and most celebrated paving brick plants west of the Mississippi River, sending millions of bricks to cities from Chicago to Denver and throughout the American southwest. By 1901, this company, owned by the Nesch family, employed 150 and had a production capacity of 100,000 paving and building bricks per day. Other significant manufacturing enterprises, many of them instituted by eastern capitalists, included the Pittsburg Foundry and Machine shops, the Pittsburg Modern Milling Company, the Hull and Dillon Packing Plant, a bicycle factory, two large ice plants, a prosperous creamery, three steam laundries, several cigar factories, carriage works, and a mattress factory.

By 1900, the Pittsburg, Frontenac and Suburban Electric Railway Company operated three lines that connected Frontenac to the north and Chicopee to the southwest to Pittsburg. A modern city hospital provided medical services and the latest in surgical procedures, while the pride of the city was the school system with four ward schools for elementary students and a high school. Plans were also in place by 1901 to erect a new high school building and an additional elementary school. A new city hall and courthouse building was also completed in 1901 at a cost of $47,000, and a Catholic hospital was erected in 1903. The little wooden shacks erected along Broadway in the city's earliest days were also quickly disappearing as the 20th century commenced, being replaced by substantial brick buildings with stone trimmings. City parks, fraternal organizations, 13 churches, theaters, a public library, daily and weekly newspapers, a state college, and many other amenities all suggested the thriving nature of the community in the two decades after 1900.

Pittsburg was also the most heavily unionized city in the state of Kansas at the beginning of the 20th century and was home to Alexander Howat, president of District 14 of the United Mine Workers of America. Numerous times, Howat led his miners out on strikes for higher wages, safer working conditions, and freedom from the patronage of the company store. He was one of the workingmen's staunchest supporters, and he was the central figure in the defeat of the Kansas Court of Industrial Relations, an arbitration court that took away the right of labor to strike in the 1920s. Labor conflicts and the ethnic diversity of southeast Kansas led Pittsburg and the entire region to be named "the Little Balkans of Kansas." Originally intended as a pejorative term, in recent times, this nickname has become a point of ethnic and historic pride for the region.

The coal industry was dealt a serious blow when the zinc smelters mostly moved westward to the Kansas gas fields before World War I. National demand for coal, however, remained high enough that the mining economy remained relatively stable through the 1920s. The underground, deep-shaft mining originally employed in southeast Kansas was difficult and dangerous. It was not uncommon for 40 to 50 men to meet with fatal accidents on an annual basis and many hundreds more to have nonfatal accidents. The coal seams below Pittsburg were typically only

two to three feet thick and situated 100 to 300 feet underground. The men usually had to work on their knees or lay on their sides. They set dynamite charges to loosen the coal and then broke it from the earth with handpicks. The coal then had to be shoveled into cars that were often pushed by boys under the age of 16 or pulled by donkeys to the elevators that hoisted the coal to the surface.

Coal, either directly or indirectly, determined the phenomenal growth of Pittsburg during its first 50 years. The extension of railroads into the city and region, the introduction of smelting and manufacturing industries, and the arrival of a large ethnically diverse population were all tied to the mining and exporting of coal. The extension of municipal interests and the development of educational facilities were also among the noteworthy examples of Pittsburg's progress and were accomplished in a comparatively short time. As Pittsburg turned 50 in 1926, however, the initial era of growth and investment was drawing to a close. Mechanized strip mining was increasingly common, and it put many of the deep-shaft miners out of work. This change and the not-too-distant economic depression of the 1930s dramatically altered the Pittsburg scene. The estimated population of Pittsburg in 1919 was 27,080. In 1940, the population decreased to 20,000. An analysis of the city directories showed that 492 business firms moved, changed ownership, or discontinued business during the period of 1919 to 1940.

The growth of a state institution of higher education, known today as Pittsburg State University, took on increased cultural and economic importance to Pittsburg as some of the earlier industries waned. Pittsburg's economy had to withstand the loss of many of its major industries during the 1930s and 1940s and a decline in its population. It recovered through the two decades following World War II, and by the mid-1960s, the city leaders were justifiably claiming that Pittsburg was "a city with a future." Throughout its history, Pittsburg has proved to be resilient. The closure of the McNally Pittsburg Manufacturing Corporation in 2002 meant the loss of a significant employer and a part of Pittsburg that had been in existence since 1889. The loss in 2008 of the community's second-largest employer, Superior Industries, is just the most recent in a long history of economic challenges. As the nation celebrated its bicentennial, Pittsburg was celebrating its centennial in 1976. Commemorative artifacts from that celebration carried the theme "Pittsburg: the Busy City." It is a theme that continues today, as Pittsburg, in recent years, has embarked upon significant revitalization programs, preserved and restored several of its historic landmarks, attracted new business and industry, and drawn national attention to the community through the academic and athletic successes of the city schools and Pittsburg State University.

One

THE SMOKY CITY

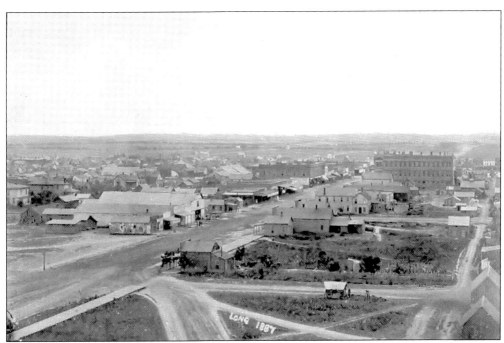

The earliest known photographs of Pittsburg were taken in 1887 by photographer Elmer E. Long. Some of the images were taken from the top of the old water tower 60 feet above the ground on West Seventh Street. The covered ice wagon in the foreground of this photograph is on West Sixth Street. The large building at the upper right was later known as the Globe building, but in 1887, it was the K-T Store, a company store of the Kansas and Texas Coal Company.

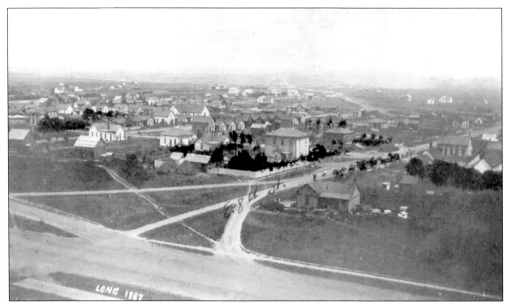

Elmer E. Long took this view of Pittsburg in 1887, looking northeast across Broadway at Eighth Street. This section of the city was one of the best residential areas at the time this photograph was taken. The second block of East Ninth Street, filled with homes in 1887, is now part of the campus of St. Mary's and Colgan Schools.

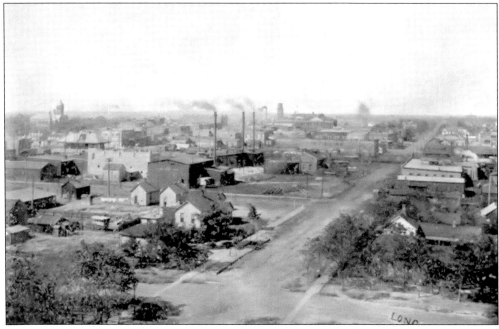

This view of Pittsburg, looking northwestward, was taken in 1901 from the top of the original three-story Washington School located at Euclid and Locust Streets. The city hall and courthouse building that no longer exists is seen in the background at the upper left. An unpaved Locust Street stretches to the north, and a St. Louis-San Francisco Railway (Frisco) freight train can be seen moving across Locust Street at Second Street.

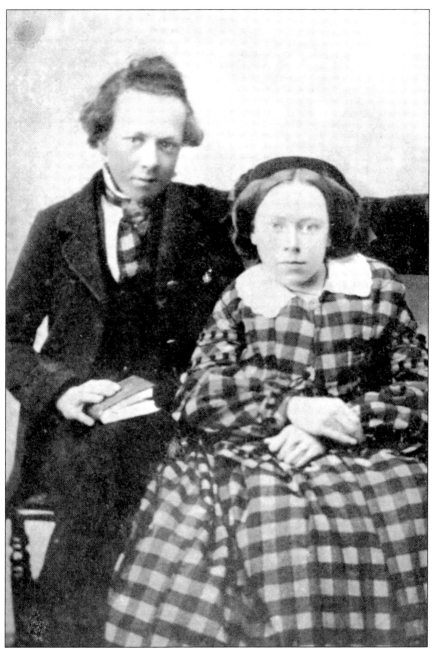

Franklin Playter was born on June 30, 1841, in Canada and studied law at Toronto University before moving to Kansas in 1868. In 1876, Playter conceived the idea of building a railroad from Girard to Joplin, Missouri, through the center of the Cherokee-Crawford coalfield. He located a town site in the center of the coalfield and named it New Pittsburg. Playter induced Jay Gould to build a line of the Missouri Pacific Railroad through Pittsburg, helped develop the city waterworks, built an opera house, promoted the development of the zinc and clay industries, started what became United Iron Works, and helped to bring the Kansas City Southern Railway into Pittsburg. In this early photograph, taken just before Playter moved to Kansas, he is pictured with his invalid sister Agnes.

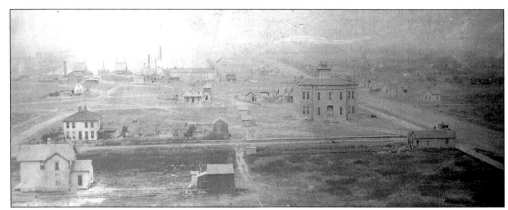

The street running across the bottom of this 1887 photograph is the 100 block of West Ninth Street. North Broadway on the right turns into a country road just past Tenth Street. The large brick building between Ninth and Tenth Streets is the North Ward School. The smelters at the upper left are the Granby smelters, located on the site where the McNally foundry was later constructed.

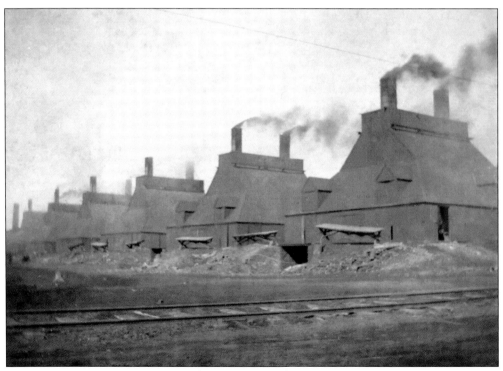

The Cherokee Zinc Company smelters, seen in this 1895 photograph, helped Pittsburg become the leading zinc-smelting city in the nation. Familiarly known as the "north" smelters, they were located on the west side of North Broadway around the 2900 block. Three other smelters were operated by the Lanyon interests in the southeast parts of the city, the St. Louis Zinc Company smelters were northeast of Pittsburg, and the Granby smelters were located on West Twelfth Street.

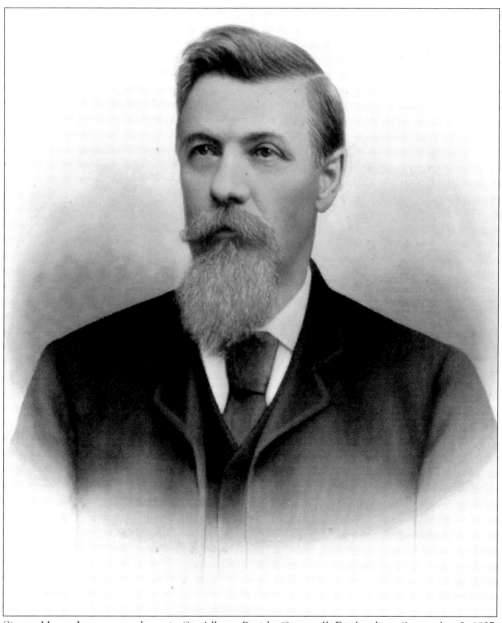

Simon Henry Lanyon was born in St. Albens Parish, Cornwall, England, on September 2, 1837. He emigrated with his parents from England to Iowa County, Wisconsin, when he was two years old. Lanyon was apprenticed to a blacksmith in Mineral Point, Wisconsin, and after learning that trade, he practiced it for about five years in San Francisco. He returned to Wisconsin in 1862 and became engaged in zinc smelting around 1870. In 1872, he shifted his zinc interests to LaSalle, Illinois, where he was associated with his uncle, Robert Lanyon. In 1876, both Lanyon men came to Pittsburg to investigate the zinc-smelting opportunities. The two men brought the first zinc smelter from LaSalle, Illlinois, to Pittsburg, where it was installed at Second and Smelter Streets. Other members of the Lanyon family moved to Pittsburg in 1877 and helped to develop extensive zinc-smelting operations and other interests, including the National Bank of Pittsburg.

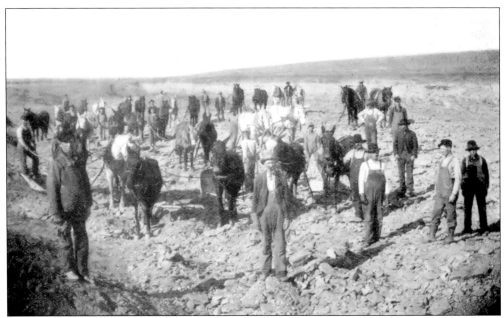

The Cherokee-Crawford coalfield has seven identified seams of coal, significant enough to be mined. In the earliest period, miners dug outcroppings of coal from hillsides, creek banks, and ravines. Where the coal was close to the surface, they used horses and mules to dredge off the shallow overburden and expose the coal by a primitive stripping method. Such was the case in this photograph taken at the J. J. Stephenson Coal Company works.

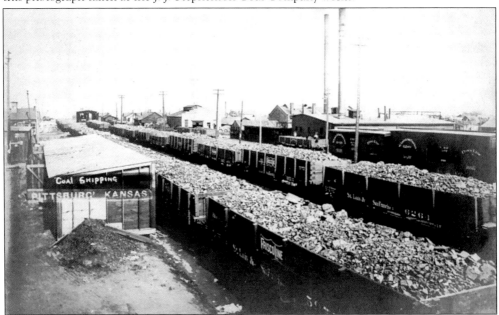

In this image, the Frisco freight yard in Pittsburg is filled with cars of mined coal. In 1914, there were 134 deep-shaft mines operating in Kansas that produced 7,186,000 tons of coal and employed 12,498 miners. More than 50 percent of the production in 1914 occurred in Crawford County. At its peak, the mining district in southeast Kansas employed 14,000 miners. In 1922, there were 280 deep-shaft mines in operation in Crawford and Cherokee Counties.

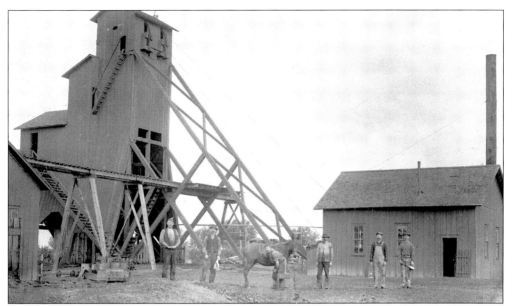

This coal tipple is typical for the coal mines operated in the Cherokee-Crawford coalfield. Mules, like the one being shoed by a local farrier, were used to pull the carts of mined coal to the hoist. The miner on the left sports the traditional carbide lamp for light in the mines. Deep-shaft coal mines operated in Crawford County for 95 years. The last of the deep-shaft mines, dismantled in 1962, was the Blue Ribbon, located about eight miles northeast of Pittsburg.

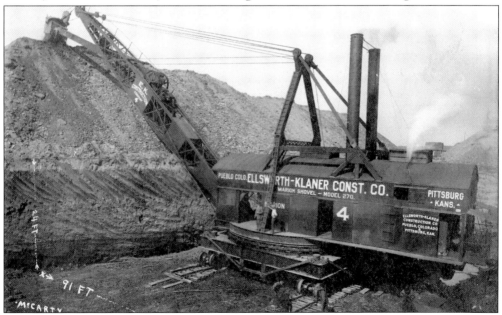

Steam shovels were common in the Cherokee-Crawford fields beginning in 1911. The early shovels weighed over 100 tons and had dippers that removed two cubic yards of overburden. They exposed approximately 200 tons of coal per day. The Ellsworth-Klaner Construction Company owned this Marion shovel, the second completely revolving shovel ever built. By the 1940s, the shovels used in southeast Kansas typically had 10 times this capacity. (Courtesy of Brenda and Robert Mishmash.)

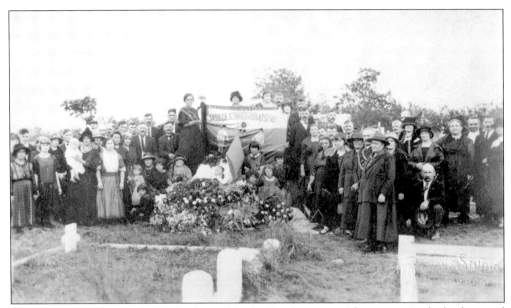

This early image shows a Slovenian funeral in the Pittsburg area. The women in the background hold a banner with the expression *Svoboda-Jednakost-Bratstvo*, which can be translated as "freedom-equality-brotherhood." French, Italian, German, Austrian, Belgian, Irish, Scot, Yugoslav, Slovene, and English were the primary immigrants in Pittsburg, but 52 distinct groups are recorded in the census, marriage records, naturalization papers, and obituaries.

Zinc smelters, railroads, brick factories, and other Pittsburg manufacturers used the locally mined bituminous coal year-round, but much of the coal also went to heat local residences and businesses during the winter months. Coal dealers, such as the Interurban Coal Company, encouraged their customers to "lay in" the coal for the coming winter season in advance so they did not face a shortage when demand peaked.

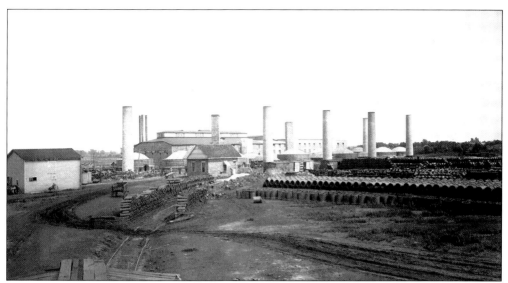

The Pittsburg Sewer Pipe and Conduit Company was incorporated in 1900 and located on East Second Street at the city limits. The plant included huge grinding machines, presses, and seven kilns built especially for the production of sewer pipe up to 36 inches in diameter and hollow bricks. The hollow brick produced by this plant is found in nearly every business structure in Pittsburg built for several decades after 1900. On the company's property, a very fine quality of fire clay was extracted from beneath a coal seam.

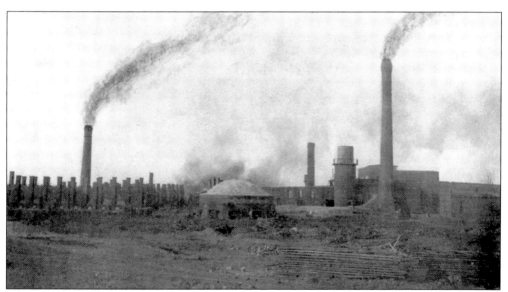

The Pittsburg Vitrified Paving Brick Company incorporated in 1890. It became the largest individual manufacturing enterprise in the city and one of the largest brick plants west of the Mississippi River. The company was established on 300 acres of clay and coal lands purchased by Robert Nesch, a Switzerland native. In 1900, the Nesch brick company employed 150 men and could produce 100,000 bricks each day. Bricks manufactured by this company were used to pave Broadway between Second and Eleventh Streets. Although Nesch bricks were distributed widely, they were especially common for paving projects in Kansas City, Missouri.

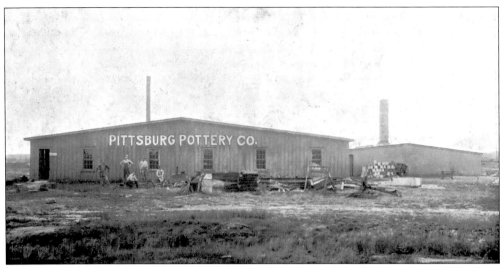

The history of the Pittsburg Pottery Company began in 1913 when a group of Pittsburg businessmen joined forces to establish a new type of industry in the city. A tract of land on the west side of North Broadway in the 2800 block was acquired, and experienced pottery manufacturers were hired to manage the operations. The company produced stoneware, flowerpots, and a variety of ornamental products that were distributed in a 20-state area of the Midwest.

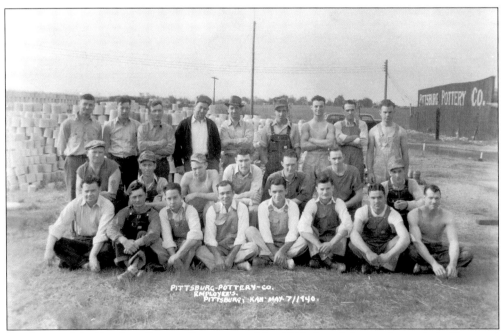

Employees of the Pittsburg Pottery Company in May 1940, from left to right, include (first row) Bert Lispi, Romeo Fernetti, Patrick McNeil, Don McNeil, Frank Anselene, Henry Slapshak, John Riffil, and Albert Leroy; (second row) Emil Fisher, William Ballock, Joseph Bell, Joseph Laird, unidentified, Jack Pryor, and G. Edward Peck; (third row) Barney Borgna, Joseph Yartz, Frank Albertini, John Dalri, Henry Matarazzi, Pete Billiard, Tony Fernetti, Jerry Mingori, and Merlyn Workman.

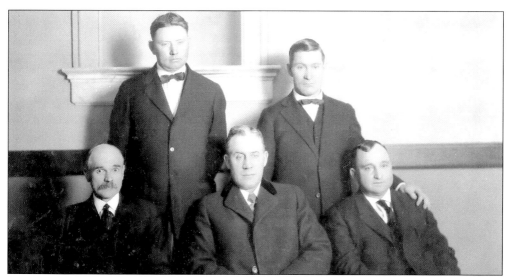

In 1921, Alexander Howat, president of District 14 of the United Mine Workers of America (UMWA), called for a strike in defiance of both national union officials and a new Kansas Industrial Court law that forbade strikes. Howat was arrested for refusing to testify before the court he believed was unconstitutional. UMWA international president John L. Lewis revoked the charters of District 14 and 81 local UMWA chapters. Howat and the leaders of District 14 who supported his position had their membership in the UMWA revoked. From left to right, local leaders included (first row) Johnny Steele, Alexander Howat, and August Dorchy; (second row) Hearl Maxwell and Joe McElwrath.

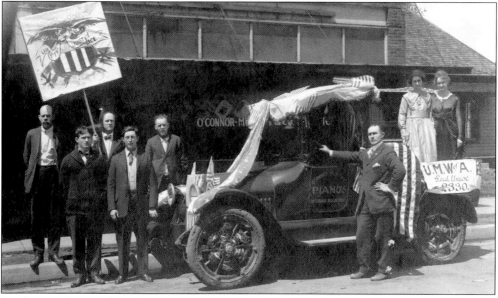

Pittsburg and most of southeast Kansas were heavily unionized. For many years, local businesses participated extensively in labor celebrations held on May Day and Labor Day. It was not uncommon for the Labor Day celebrations in Pittsburg to attract nearly 20,000 people. In this photograph, Michael Murphy and employees of the O'Connor-Murphy Piano Company of Pittsburg and Mulberry prepare to enter their decorated delivery truck in one of the parades, supporting Local 2330 of the UMWA.

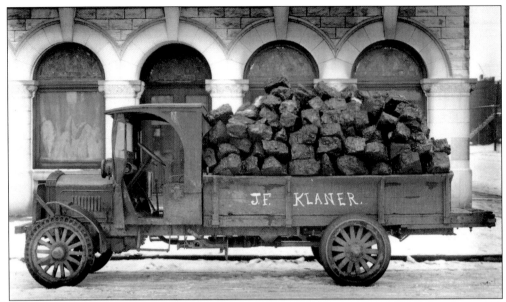

Joseph F. Klaner Sr. entered the coal strip mining business with Alfred C. Ellsworth in 1910. Before World War II, the company shifted its coal operations to the Alston Coal Company and the Kelly-Carter Coal Company, both managed by Joe F. Klaner Jr. In this photograph taken in front of the Klaner Coal Company offices in the Globe building, a Klaner delivery truck is loaded with blocks of coal. No other record of the Pittsburg Block Coal Company has been located. (Courtesy of the Crawford County Historical Museum.)

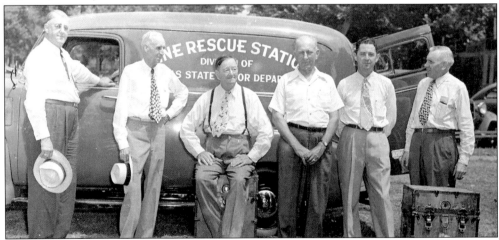

Coal mining was dangerous. Every year, hundreds of accidents occurred in the Cherokee-Crawford coalfield, many of them fatal. In January 1918, the state legislature made a $20,000 appropriation to erect a mine safety and central rescue station at the state normal school in Pittsburg. In January 1920, an additional $12,000 was appropriated to complete the building. The rescue station was moved to Arma in 1930, but a state mine inspection office remained on the campus for many years. In this photograph, believed to have been taken in the late 1930s, mine officials and educators pose in front of a rescue van. The man seated is believed to be Andrew H. Whitesitt, professor of industrial arts, and on the far right may be Everett E. Stonecipher, director of extension classes and rural education at the college. (Courtesy of the Crawford County Historical Museum.)

Two

ALL ABOARD

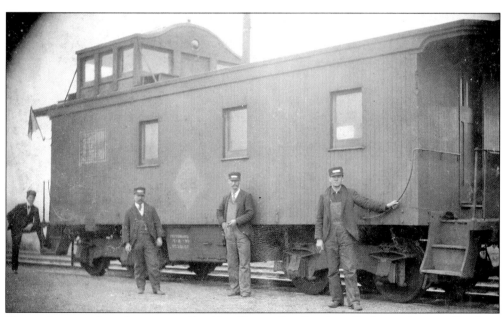

The engineers and conductors stand beside a Kansas City Southern Railway caboose in Pittsburg in 1904. The emblem on the side indicates this caboose is part of the Kansas City to Port Arthur, Texas, route.

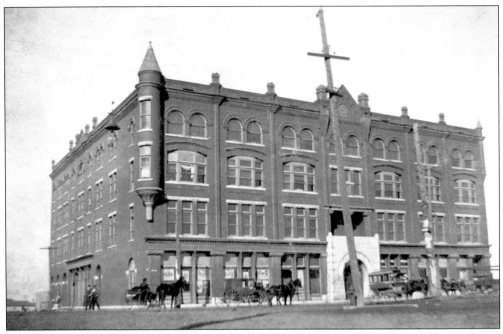

This photograph, taken by Hans Robyn in October 1895, shows a variety of horse-drawn conveyances parked in front of the Hotel Stilwell. Broadway and Seventh Street remained unpaved at the time this image was taken. Directly in front of the entrance to the hotel, a horse-drawn omnibus is parked.

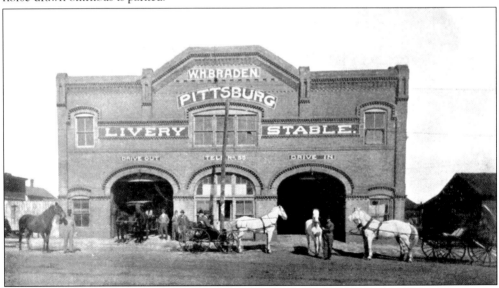

Livery stables and blacksmiths were once a prominent part of Pittsburg's economy. The community depended upon horsepower for transportation, deliveries, and construction projects. While the number of horses in Pittsburg was much higher in earlier periods, in 1924 the *Pittsburg Daily Headlight* estimated there were approximately 700 horses residing within the city limits. Added to those owned by farmers in the area, this large number of horses kept seven blacksmith shops busy. The blacksmiths estimated that probably half the horses in Pittsburg in 1924 were used to transport coal to businesses and residences in the city.

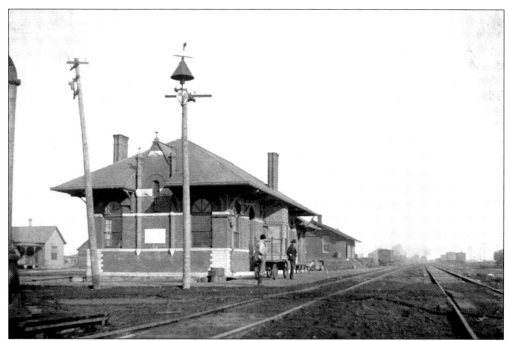

The Kansas City, Pittsburg and Gulf Railroad of Arthur Stilwell reached Pittsburg in 1893. This photograph of the passenger station located at Seventh and Michigan Streets was taken two years later in 1895. The name of the railroad was changed to the Kansas City Southern Railway in 1900.

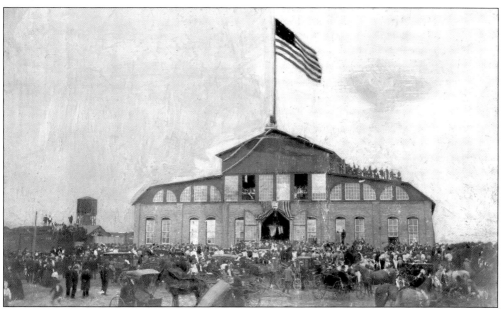

This image of the Kansas City, Pittsburg and Gulf Railroad shop was taken in 1898, one year after the building was constructed. The crowd that gathered celebrated the dedication of the building and honored the local soldiers leaving for service in the Spanish-American War. For many years after the railroad became the Kansas City Southern Railway in 1900, the shops were referred to as the P&G shops.

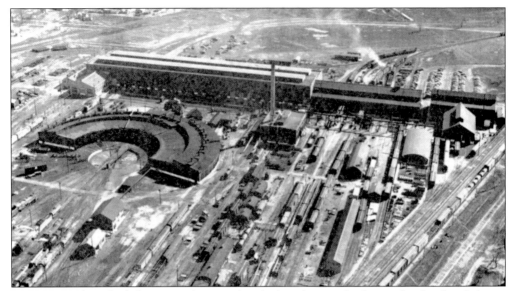

In 1892, Pittsburg had three significant railroads, but the city leaders realized a fourth being built from Kansas City to the Gulf of Mexico by Arthur Stilwell was about to bypass them to the east. Franklin Playter approached Stilwell and induced him to change his plans. Pittsburg was incorporated into the name of the railroad—the Kansas City, Pittsburg, and Gulf—when the line built into the city in 1893. The city of Pittsburg was made the railroad's headquarters for the 433-mile northern division. This aerial photograph of the roundhouse and shops was taken in 1951.

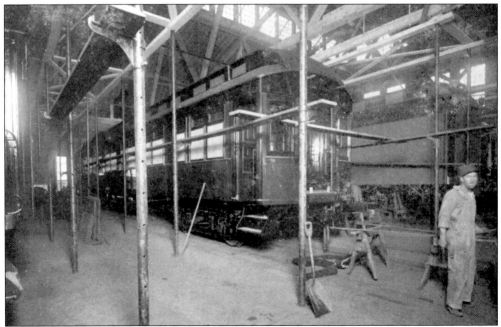

Inside the Kansas City Southern Railway shops, a passenger car was being repaired in 1914 when this photograph was taken. In 1925, the railroad employed 1,307 people in Pittsburg. The shops and yards of the Kansas City Southern in Pittsburg covered 300 acres by 1949 when the facility added new diesel repair and servicing facilities.

Employees of the Kansas City Southern Railway freight depot pose for this photograph taken around 1920. The freight depot at Sixth and Locust Streets was constructed in 1907.

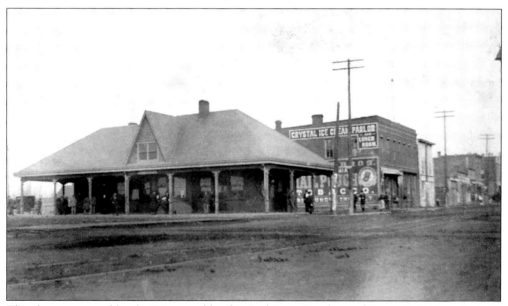

This depot was used by the Frisco and by the Atchison, Topeka, and Santa Fe Railway in 1895 when this image was taken. Among the major railroads, the Frisco claimed to be the first in Pittsburg by way of its purchase in 1879 of the Joplin and Girard Railroad on which line the city was established in 1876. The Santa Fe railway arrived in Pittsburg in 1886. This depot sat approximately upon the site of the present-day Miner's Memorial and Immigrant Park Pavilion and served as an architectural inspiration for the pavilion.

THE JOPLIN-PITTSBURG RAILROAD LINES

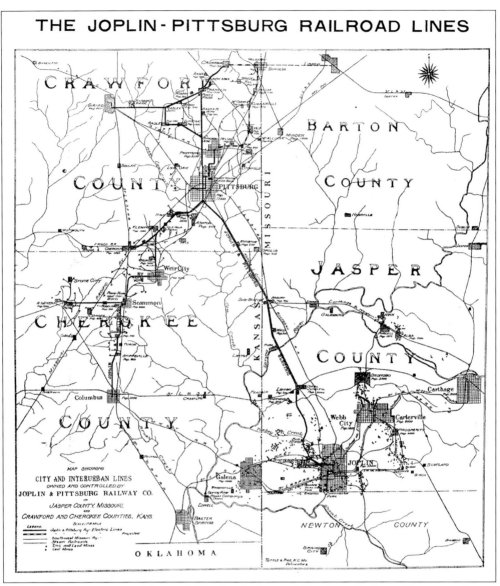

Before motorcars were widely available, the Joplin and Pittsburg Railway Company electric interurban was a principal means of transportation and shipping for thousands of persons throughout the area. The Joplin and Pittsburg Railway Company began operations in July 1907 and expanded throughout Crawford and Cherokee Counties in Kansas and Jasper County in Missouri. In 1909, when this map was drawn, the line controlled 110 miles of track and provided inexpensive and convenient connections for the 200,000 residents of the region. In 1932, the passenger business was discontinued and the tracks removed from Pittsburg's streets. The freight lines continued to operate for several more decades.

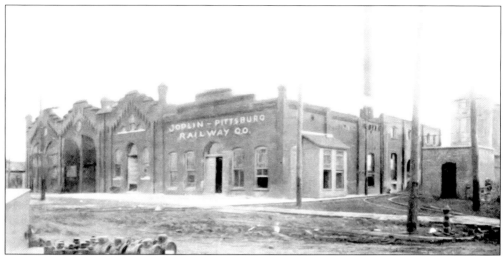

Much of the capital for the development of the Pittsburg, Frontenac and Suburban Electric Railway Company came from residents of West Chester, Pennsylvania. Organized in July 1894, the new electric interurban purchased the Forest Park Electric Railway at a receiver's sale and extended the former company's track four miles north to Frontenac. In September 1895, the Pittsburg, Frontenac and Suburban purchased the Broadway line from the Pittsburg Electric Railway Company and began the extension of its lines to mining camps and communities throughout the region. This photograph, taken around 1910, shows the electric powerhouse constructed by the Pittsburg, Frontenac and Suburban Electric Railway Company that became the property of the Joplin and Pittsburg Railway Company.

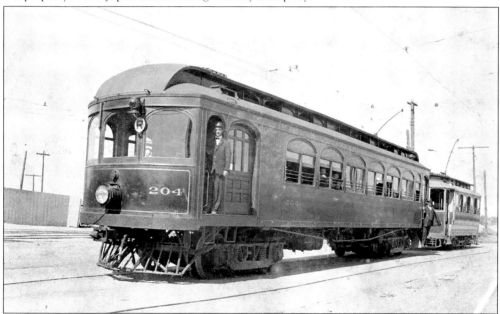

This Joplin and Pittsburg Railway Company airline car was one of the premier passenger conveyances during the second and third decades of the 20th century. Running from Seventh Street and Broadway in Pittsburg to Seventh Street and Main in Joplin, the airline cars averaged a mile a minute from city limit to city limit and made four stops along the way. The Joplin and Pittsburg Railway Company employee on the front of the car is identified as Jesse Smith.

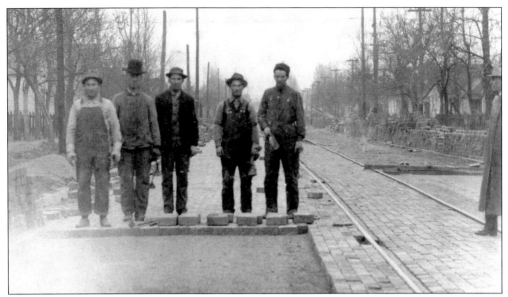

In the early days of Pittsburg's history, street pavers first pressed down a six-inch layer of cinders. The first layer of bricks was laid flat over the cinders and covered with a one-inch layer of sand for a cushion. The top course of vitrified bricks was laid edgeways. The bricks were rolled with a heavy roller and sand was used to fill the gaps between the bricks to allow for expansion and contraction. The first street-paving project in Pittsburg began in 1891 when the two-course covering of brick was laid on Broadway from Second to Eleventh Streets. This project photographed on West Ninth Street occurred several years later.

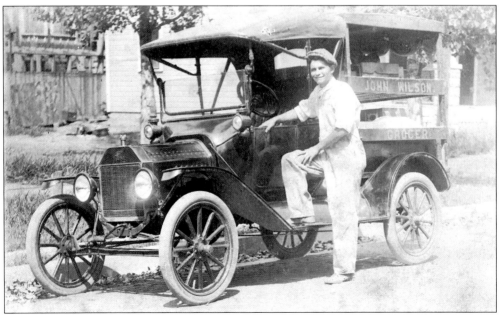

This photograph of Jess T. Blancett was taken in the early 1920s. Blancett was a deliveryman for grocer John Wilson. Competition in the grocery business was keen. The 1923 city directory lists one fish market, three retail fruit stores, 11 meat markets, and 106 retail grocers. (Courtesy of Brenda and Robert Mishmash.)

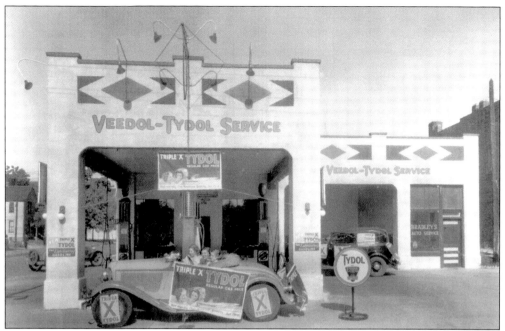

Vern and Ray Bradley operated Bradley's Auto Service at 102 East Ninth Street in 1933 when this photograph was taken. The national average for a gallon of gas was 18¢. The three occupants of the roadster are identified as Mary Dean, Virginia, and Mary Shirk. Tydol Gasolines and Veedol Lubricating Oil were products of the Tidewater Oil Company.

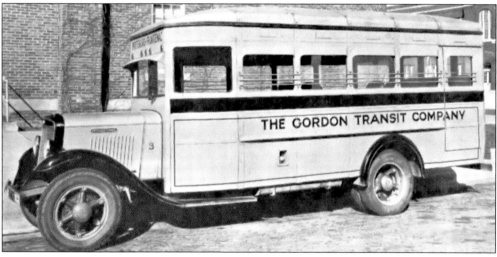

Maynard W. Angwin, president of the Gordon Transit Company, conceived the idea of establishing a city bus service in the spring of 1933. Angwin was completing a degree at the Kansas State Teachers College, now Pittsburg State University. He was a member of the student newspaper staff and was writing an article concerning the last passenger run of the Joplin and Pittsburg interurban when he realized the necessity of some other means of travel. The company began operations on June 5, 1933, with Gordon Angwin as president and Maynard W. Angwin as vice president. Operations began with two 17-passenger buses. One of the original buses is shown in this photograph taken in 1935. The company had eight buses and 17 employees by 1940.

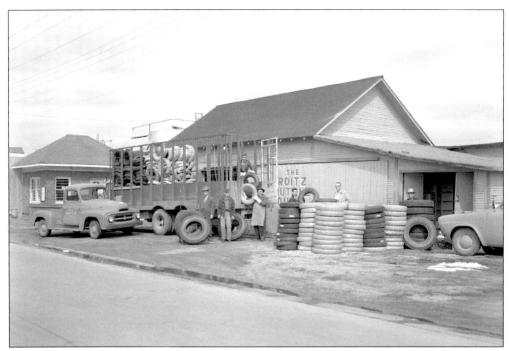

Anton F. Roitz operated the Roitz Oil, Butane and Tire Wholesale Company at 401 South Joplin Avenue. A shipment of new tires was being unloaded when this photograph was taken on March 16, 1958.

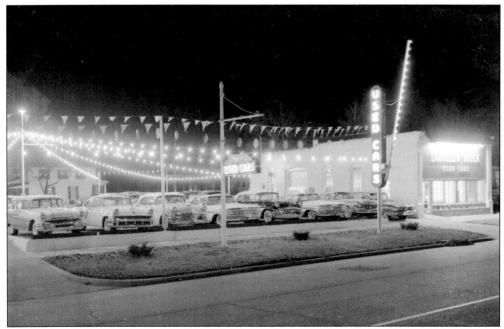

On a Sunday evening, November 8, 1959, photographer William Parrish took this image of the Laughlin Buick Motor Company used car lot. Otis W. Laughlin Jr. and his wife, Jacqueline, sold new and used cars at Laughlin Buick. They operated lots at 525 South Broadway and at 701 South Broadway.

Three

A BUSY DOWNTOWN

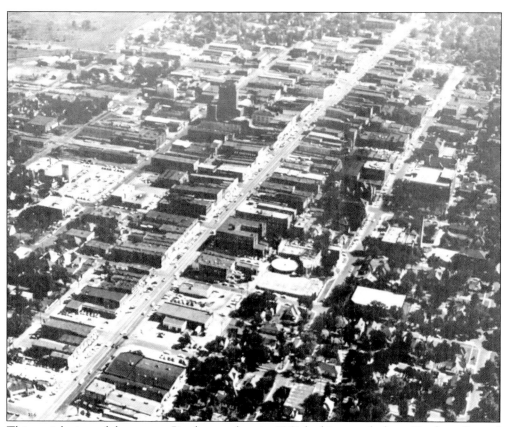

This aerial view of downtown Pittsburg, taken in 1959 looking south from Tenth to Second Streets, is evidence of a busy downtown district. The major thoroughfares of Broadway and Walnut, Locust, and Joplin Streets that run north and south are plainly visible. So are familiar landmarks, such as the Hotel Stilwell at Seventh Street and Broadway, the post office on East Seventh Street, and the Besse Hotel on East Fourth Street.

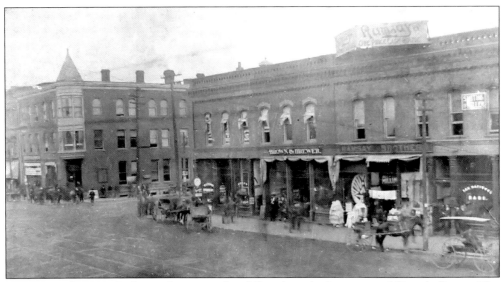

This 1895 photograph shows the east side of Broadway looking toward Fourth Street. The First National Bank, on the far right, was incorporated in 1886. Its officers were J. R. Lindburg, president; J. W. Brewer, vice president; Charles P. Hale, cashier; and A. E. Maxwell, assistant cashier. Lindburg and Brewer were two of Pittsburg's earliest residents, arriving in 1877 and 1879. Lindburg was born in Sweden and came to Pittsburg when the town had 50 residents. Brewer was one of the leading city merchants, being a part of the grocery firm of Brown and Brewer. The National Bank of Pittsburg is shown at far left.

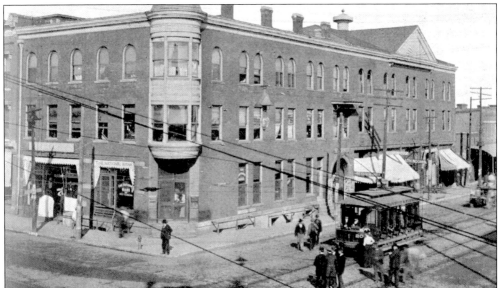

Here is the intersection of Fourth Street and Broadway as it appeared in 1901 with the National Bank building as a backdrop. The streetcar is shown in its summer style with open sides and bench seats running the width of the car. The bank building was constructed by Franklin Playter and J. Foster Rhodes of Chicago in 1888. While the lower level was home to the National Bank and Playter's business office, the upper floors were originally known as Rhodes Opera House. After the LaBelle Theater was constructed in 1903, the second floor of this building was used as office space, and the third floor became a lodge hall and a rooming house.

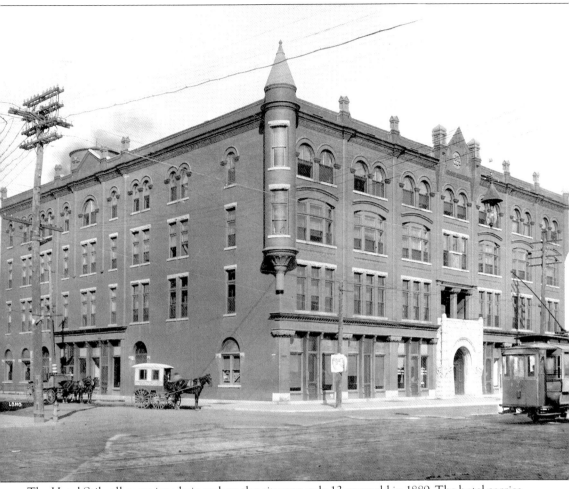

The Hotel Stilwell came into being when the city was only 13 years old in 1889. The hotel carries the name of its principal financier, Arthur E. Stilwell, who built the Kansas City, Pittsburg, and Gulf Railroad. The hotel drew many travelers for business and social reasons and quickly became a focal point for the town's elite social life. The four-story structure of red brick was trimmed in Carthage stone and contained over 100 rooms, including those on the main floor used as business offices. During the most turbulent era of labor disputes in 1920, Kansas governor Henry J. Allen established his office on the third floor of the hotel for three weeks so that he could be on the scene at all times. An ice wagon and a delivery carriage for the Pittsburg Steam Laundry are parked on the south side of the hotel while a Pittsburg, Frontenac and Suburban trolley runs down Broadway.

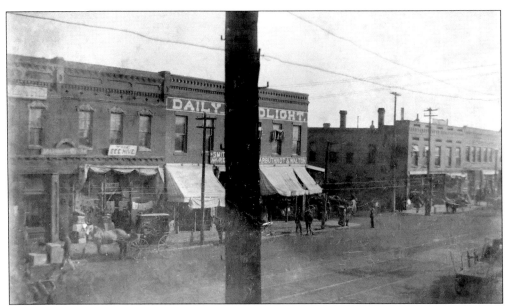

Millard Fillmore Sears came to Pittsburg in 1883 and taught in country schools before founding the *Pittsburg Daily Headlight* newspaper in 1885 with his brother W. F. Sears and cousin Harry Sears. In 1888, William Moore, a veteran newspaper publisher, purchased the Searses' interests in the newspaper and began operation with his three sons. The Moore family continued to publish the newspaper from the second floor of this building, located on the northeast corner of Third Street and Broadway until 1899.

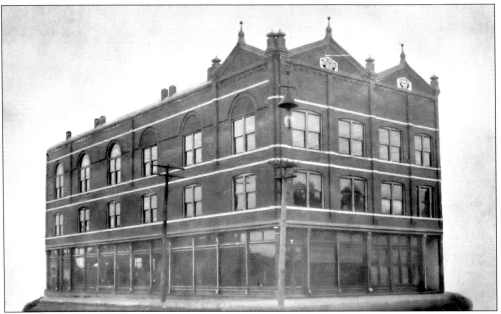

In 1899, the *Pittsburg Daily Headlight* moved to a new building at Seventh Street and Broadway, which had a great expanse of plate-glass windows on the north. For many years, Pittsburg residents passed by to watch the newspaper operations through the windows. Linotype machines were located next to the windows, permitting residents to observe the operators setting news items in metal type.

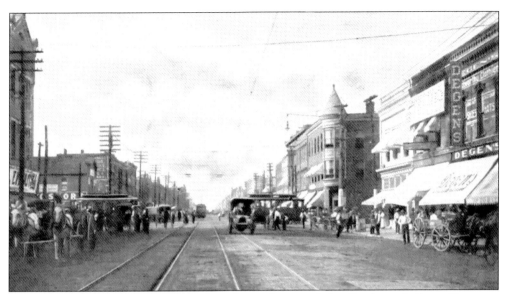

On March 20, 1890, the Pittsburg City Council granted the Pittsburg Railway Company the right to operate an electric railway on Broadway. B. F. Hobart, president of the Pittsburg Town Company and investor in the Cherokee Zinc Smelter Company, was president of the Pittsburg Railway Company. The decision was made to double-track Broadway from Second to Tenth Streets. In 1891, the city council awarded Dr. George W. Williams and his partners the rights to develop the Forest Park Electric Company trolley system that ran east and west along Fourth Street.

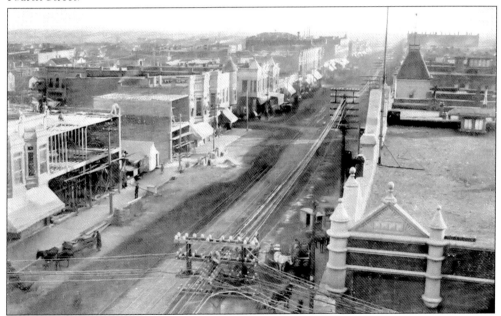

This photograph, taken in 1901 from the top of the Hotel Stilwell, shows Broadway when Pittsburg was 25 years old. A multitude of telephone wires and power lines run down the west side of the street. The Globe building at Fourth Street towers in the right background. Most of the original buildings on Broadway were already replaced by more significant structures in 1901.

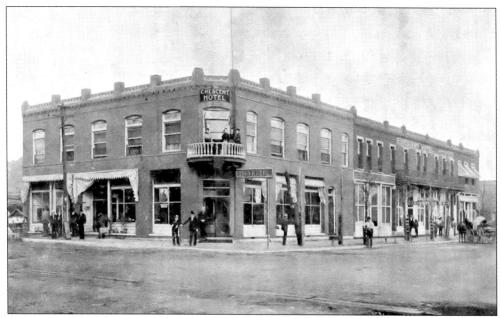

The large numbers of immigrants and travelers passing through Pittsburg on the city's numerous railroads led to an abundance of hotels. In 1899, the Crescent Hotel, one of the city's oldest, was purchased by William and Lydia E. Miller. Remodeling and an extensive addition were completed by 1901 in time for this photograph. The hotel offered accommodations for 100 guests at rates of $1 or $1.25 per day.

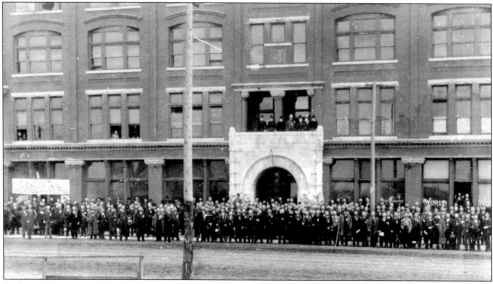

In late February 1892, Pittsburg welcomed members of the Ancient Order of United Workmen (AOUW) from Kansas for their 14th annual convention. The Hotel Stilwell was crowded with 700 AOUW members who attended. Broadway, from Second to Seventh Streets, was decorated with emblems, flags, banners, and bunting. In 1892, there were 343 AOUW lodges with about 20,000 members in the state. About 270,000 members in the United States and Canada were banded together primarily for the purpose of caring for the sick, burying the dead, and providing for the widows and orphans of the membership.

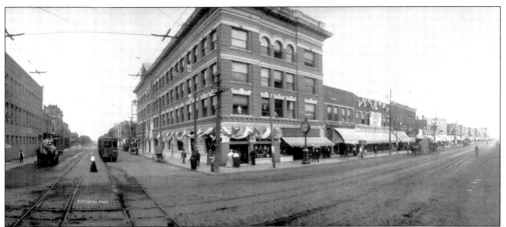

In this photograph taken in 1909, a horse-drawn water tank and a trolley car proceed along West Fourth Street. Clearly visible above the intersection are the electric lines that powered the interurban trolley cars. The large four-story Commercial Building on the corner remains to this day, occupied partially by the Crowell Drug Store.

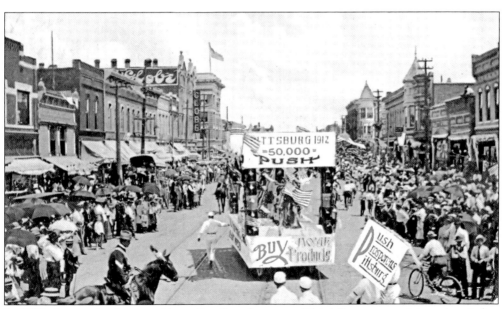

In 1909, thousands of area residents line Broadway near Third Street to participate in a Labor Day celebration. Local boosters encouraged residents to buy local products and "Push Prosperous Pittsburg." A sign on the float optimistically hopes that the population of Pittsburg could be doubled to 50,000 by the year 1912.

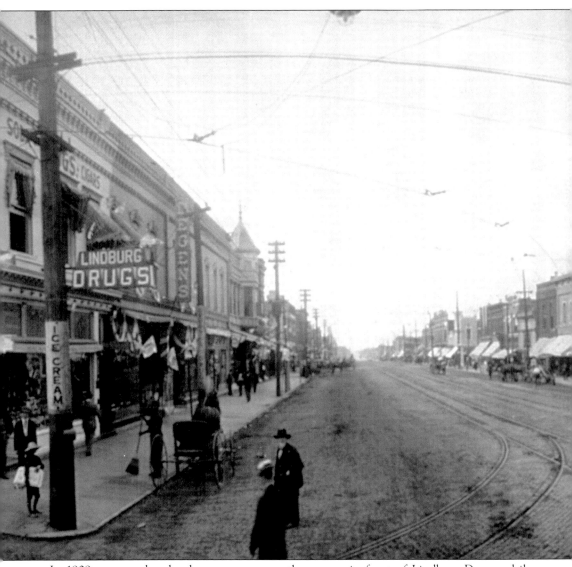

In 1909, a young boy hawks newspapers on the corner in front of Lindburg Drugs, while a second young man sweeps the sidewalk. Across the street, the Globe building is covered with decorations to welcome a meeting of the United Commercial Travelers (UCT). The UCT was organized in Columbus, Ohio, in 1888 by eight men, each of whom contributed $5 and agreed

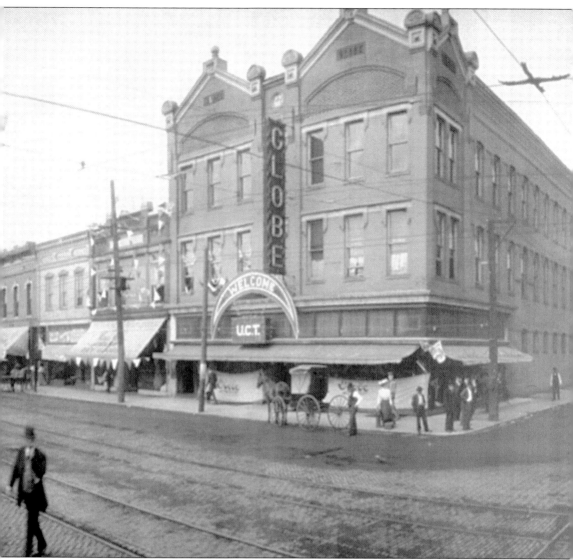

if any one of them was injured in an accident and was unable to carry on his work as a traveling salesman, the others would contribute $5 a week until the incapacitated member was able to return to his work. A charter from the international organization was granted to Pittsburg in July 1894, being the 77th chapter in the country.

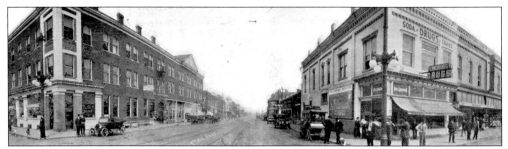

The intersection of Fourth Street and Broadway has always been the center of activity in downtown Pittsburg, even when John R. Lindburg arrived in Pittsburg in 1877. In addition to opening a drugstore at that intersection, he was founder of the Commercial Club, member of the first city council, president of the Pittsburg Building and Loan Association, president of the First National Bank, and, with his associates, erected 10 brick business houses and about 200 homes before he died in 1915. Degens, next to Lindburg Drugs, was a men's apparel store founded by Harry Degens in 1900.

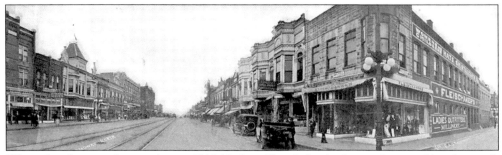

When this photograph was taken in 1914, Nathan Fleischaker had recently moved his dry goods store from 319 North Broadway to the old National Bank building on the corner of Broadway and Fourth Street. Extensive remodeling had occurred on the front of the building, providing display windows and a more modern entrance. C. E. Finley and Company was located next door. Charles E. Finley and Samuel W. King handled paints, oils, glass, wallpaper, and picture frames at 604 North Broadway. Belle Clendenin, a milliner, had the next shop to the north followed by Bile's Brothers bakery and Beasley and Miller's hardware store.

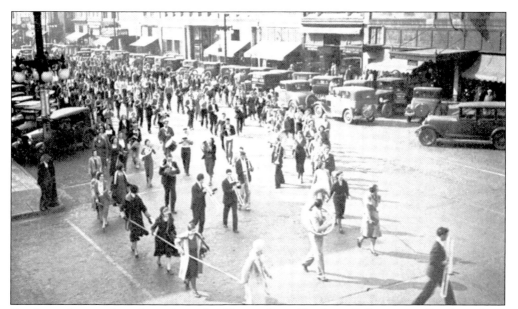

Band members and students from the Kansas State Teachers College, now Pittsburg State University, weave their way through the traffic in downtown Pittsburg in the fall of 1931. A pep rally before an upcoming football game was most likely the impetus for the march.

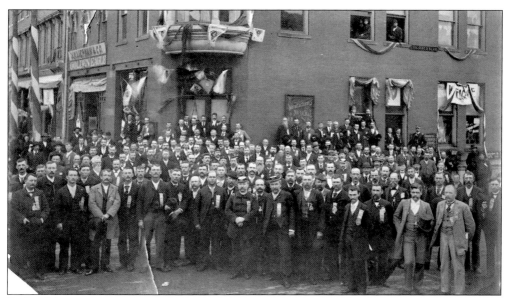

Each of the passenger trains arriving in Pittsburg on May 16 and 17, 1892, carried delegations from across the state to attend the 21st annual session of the Grand Lodge of Kansas, Knights of Pythias. Nearly 850 knights and 150 Pythian sisters attended. The Knights of Pythias was a secret society formed in Washington, D.C., just 28 years earlier to promote the principles of friendship, charity, and benevolence. In 1892, the Pythians claimed a national membership of 400,000. In Pittsburg, the membership jumped from 97 to 300 during the two-month period before the state session. Some of the 850 attending Pythians posed for this image in front of the opera house built by Franklin Playter and J. Foster Rhodes in 1888. (Courtesy of Brenda and Robert Mishmash.)

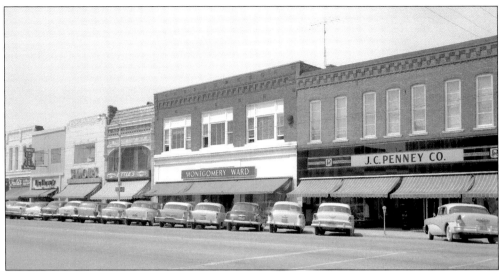

The west side of Broadway between Fifth and Sixth Streets contained many national and local stores familiar to the residents of Pittsburg. When the J. C. Penney Company first came to Pittsburg in 1916, it was located on West Fourth Street. Of all the stores in this photograph from 1959, only Little's continues at the same location in 2008.

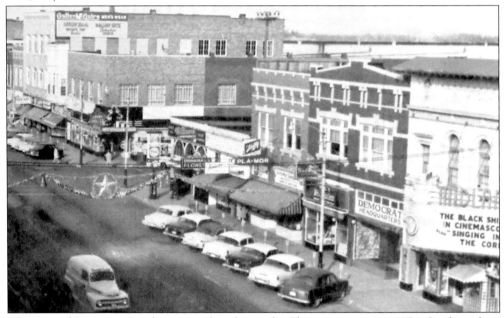

This view of downtown Pittsburg was taken during the Christmas season in 1954. On the right is the Midland Theater, formerly known as the Klock. It was the first theater in Pittsburg to convert from a pipe organ to sound in the 1920s. Between the Midland and Al William's Jewelry store was the Pla-Mor pool hall and bar, one of the most popular establishments in Pittsburg. The Pla-Mor began in 1904 as Robert Cherry's Smoke House and was a particular favorite of many of the local miners. It moved to this location in 1927. In 1950, the name changed to the Pla-Mor, but the clientele was largely college students long before that time. The Coulter-McGuire Clothing Company, advertised on the tall building at the top of the image, was established in December 1910 by Hugh A. McGuire and O. E. Coulter.

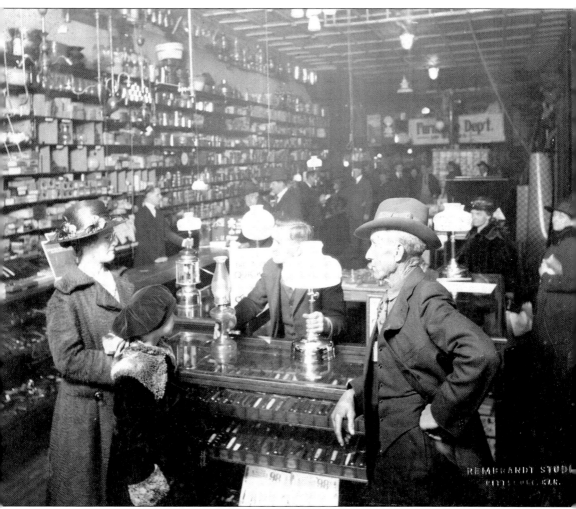

Business was booming at Sell and Sons hardware when this photograph was taken. John Sell, shown holding the two lamps, earned the nickname "Mr. Hardware." Sell worked in the coal mines as a youngster before taking a position with pioneer Pittsburg merchants John H. Beasley and Melvin D. Miller about 1903. In 1913, Sell left to open the Sell-Atkins Mercantile Company. In 1923, he purchased the full interest in the business, which he renamed Sell and Sons.

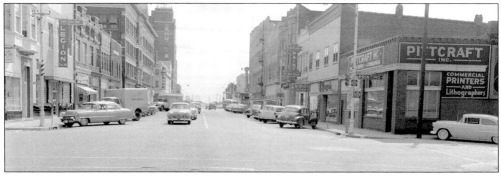

This photograph of Fourth Street taken in August 1957 shows a busy downtown district. On the left, the Hotel Besse towers over downtown Pittsburg, and an advertisement for KOAM Radio is prominently displayed on the Commercial Building. E. Victor Baxter founded KOAM Radio in 1937. It was one of the earliest stations in the area. The station was later moved from downtown Pittsburg to a new broadcast facility four miles east of Pittsburg on Highway 126.

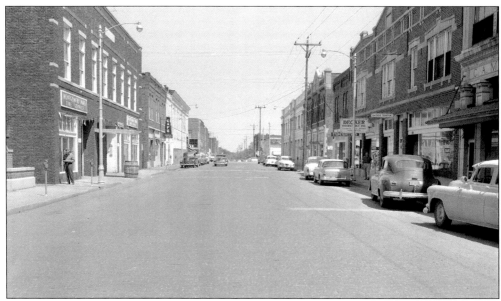

This photograph of West Fifth Street was taken in May 1958. Just past the Montgomery Ward auto service department was the Chloe and Johnnie Café, operated by John and Chloe Pellegrino, and Emile's Barbershop, operated by Emile Castellani. These business owners reflected the significant ethnic immigrant heritage of Pittsburg, just as the Labor Temple located at 115 West Fifth Street reflected the heavy unionization of the city. Among the 20 labor union organizations still with offices in the Labor Temple in 1958 were the Brotherhood of Locomotive Engineers, the International Typographical Union, and the United Association of Plumbers and Steamfitters.

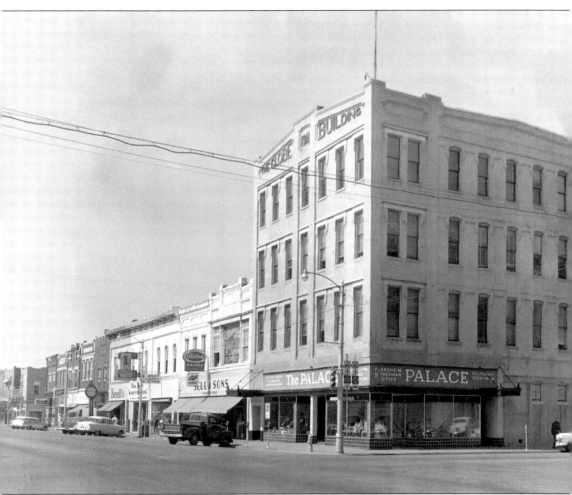

The Globe building, located at Fourth Street and Broadway, first existed as the K-T Store, a company shop for the Kansas and Texas Coal Company. In 1911, the front of the building was significantly remodeled from how it appeared in the 1909 photograph on page 41. In addition to Pittsburg, the Globe Shoe and Clothing Company had stores in Wichita, Iola, and Weir, Kansas. Over the years, the building was home to many professional offices, coal company offices, and general merchandise stores. In 1958, when this photograph was taken, the lower level was home to a clothing and accessory store called the Palace. The Globe building was demolished in 1965.

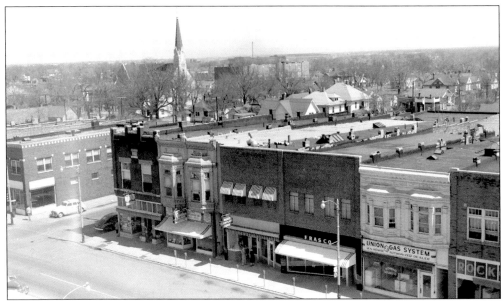

The tall steeple in the center is part of St. Mary's Church, now known as Our Lady of Lourdes Catholic Church, at Ninth and Locust Streets. To the right is the St. Mary's School building, constructed in 1922. The third floor of the Catholic school building was added a few years later, and high school classes were instituted in 1936. Over the school in the distance are the roundhouse and shops of the Kansas City Southern Railway.

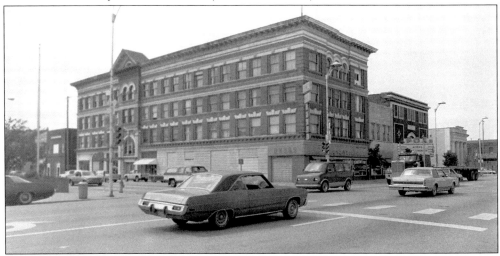

In January 1890, the drugstore of Dry and Crowell opened in a frame building at Fourth Street and Broadway. The partnership was of short duration, and Thomas J. Crowell became the sole proprietor of the firm. Crowell's continues today in the Commercial Building as the oldest business institution in Pittsburg in terms of continuous operation. Thomas J. Crowell, who died in 1938, was succeeded by his son Paul A. Crowell. In 1914, the Crowells purchased the Ash Drug Store, which was the second-oldest drugstore in Pittsburg at that time, being established by Lou Ash in 1896. In 1950, it was estimated that the two drugstores combined had filled over 2.5 million prescriptions for local residents. The Colonial-Fox Theater, to the right of the Commercial Building, was placed on the National Register of Historic Places in 2008 and is currently undergoing renovation.

Four

MOVERS AND SHAKERS

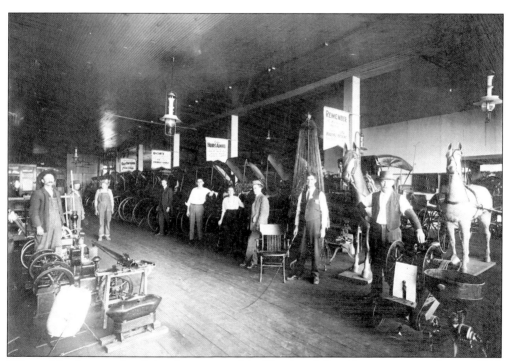

When this photograph of the showroom of A. Hood and Son Company was taken in 1914, Archibald Hood and his son Edgar C. Hood were well established in Pittsburg as wholesale and retail dealers in buggies, wagons, and farm implements. The primary interest of the business, located at 607 and 609 North Broadway, shifted to Buick automobiles within a few years. The wooden horses seen on the right of this photograph frequently appeared in parades in Pittsburg during the second decade of the 20th century to advertise the Hood family business.

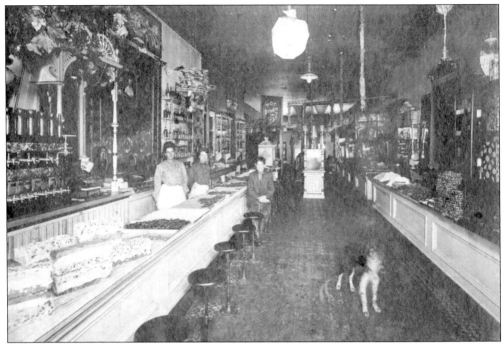

The Star Candy Kitchen was founded in 1901. Homemade candies and confectionaries were the specialties served at 506 North Broadway. George Pappadakes was the manager of the business.

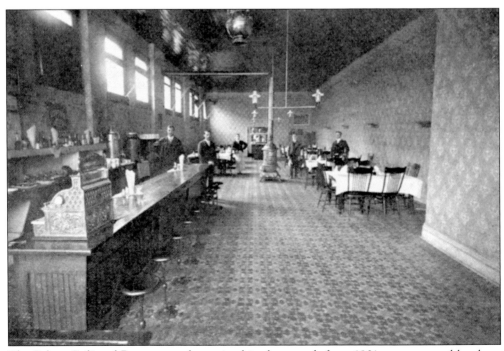

The Palace Café and Restaurant, shown in this photograph from 1901, was operated by three brothers, Harry H., James A., and Van Warren Minkler. Advertisements for this eatery, located at 501 North Broadway, said it was "open day and night."

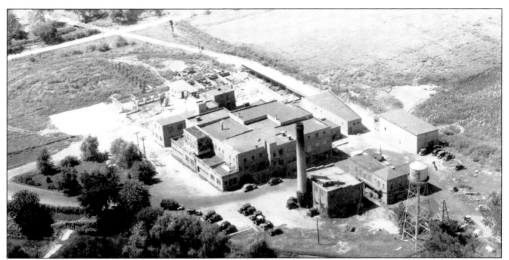

Lewis Hull came to Pittsburg from Wheeling, West Virginia, in 1885 to open a local butcher shop. Thomas J. Dillon, his brother-in-law, arrived in Pittsburg in 1891. Believing they saw an opportunity for building up a wholesale packing business, they formed a partnership that became the Hull and Dillon Packing Company. By 1901, the firm employed over 30 men and occupied a 10-acre tract on the west edge of the city. Their pork products were marketed under the names of Blue Ribbon hams and Enterprise bacon. Dillon sold his interest in the business in 1918. By 1925, the packinghouse was processing 25,000 hogs and 5,000 cattle annually. This aerial photograph was taken in 1938.

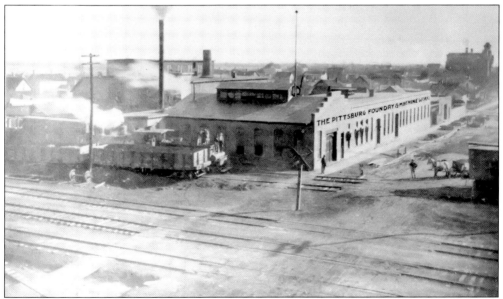

In the early 1880s, a small shop located south of the Frisco railroad tracks on Locust Street began making picks for the local miners. Charles Chapman and C. G. Emerson of Kansas City purchased the shop and renamed it the Pittsburg Foundry and Machine Company. The company grew and in 1903 was purchased by the United Iron Works of Springfield, Missouri. By 1926, this firm employed 300 men in Pittsburg who manufactured coal-mining, zinc-mining, and brick-making equipment.

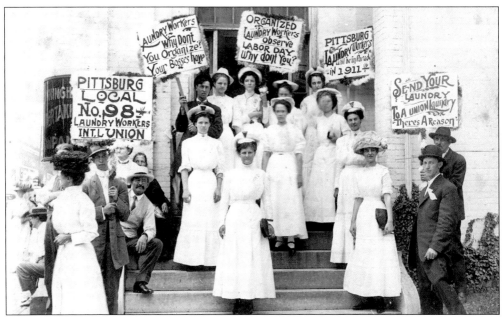

Members and friends of the Pittsburg Local No. 98 of the International Laundry Workers Union gather on the steps of the White Star Laundry at 214 North Broadway in 1911. Pittsburg was the most heavily unionized city in the state of Kansas in the early 20th century and hosted Labor Day parades and celebrations that drew thousands of participants from the southeast Kansas and southwest Missouri regions. The laundry workers in this picture, including sisters Ida and Ruth Seybold who worked as ironers at the White Star Laundry, prepare to carry their placards in the parade.

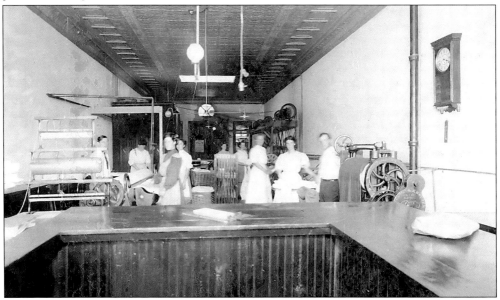

This photograph, taken about 1920, shows the interior of the Pittsburg Steam Laundry at 110 North Broadway. The Pittsburg Steam Laundry was established in 1890 by Otto Greef and employed two delivery wagons and a workforce of 12 when it opened. (Courtesy of the Crawford County Historical Museum.)

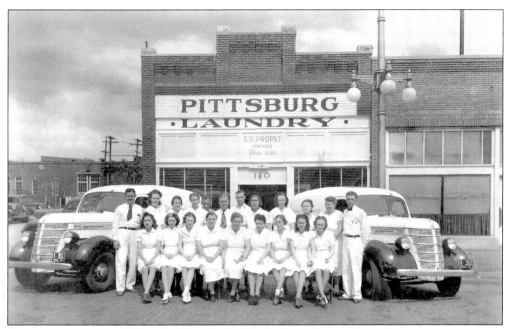

Sometime between 1936 and 1938, Eli Rush's Pittsburg Steam Laundry was taken over by Shelton D. Probst. In May 1940, Probst and his staff pose for this photograph in front of the business. The company used the two cars seen here for pickup and delivery service throughout the city.

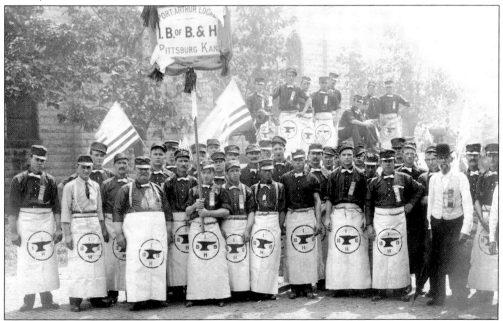

Pittsburg hosted numerous labor union conventions in its early history. In this photograph from about 1895, a gathering of the International Brotherhood of Blacksmiths and Harnessmakers is documented. "Port Arthur Local" on the banner comes from the fact that the Kansas City, Pittsburg and Gulf Railroad, later known as the Kansas City Southern Railway, which ran through Pittsburg, was known as the Port Arthur (Texas) route.

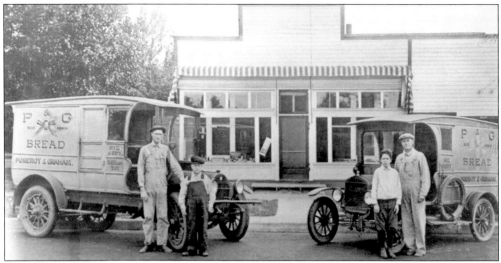

On March 7, 1906, Harry Pomeroy and Charles E. Graham opened the P&G Bakery in Pittsburg with $50 from Pomeroy and $100 from Graham to capitalize their venture. Both men were born and raised in Pittsburg, had worked for the old City Bakery, and, as adults, became brothers-in-law. By 1926, the P&G Bakery had a fleet of seven trucks and delivered their P&G Certified, Blue Ribbon, and Life O' Wheat brand breads to 33 towns in the region.

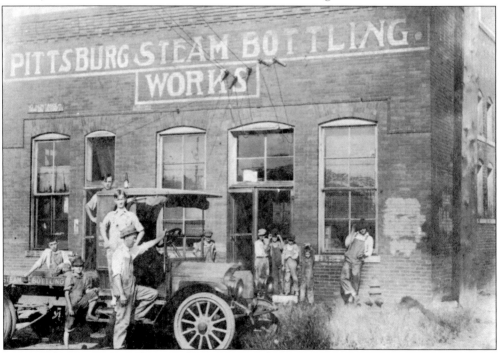

The Pittsburg Steam Bottling Works at 202 North Elm Street was organized before 1901 by John Lontkowsky and John H. Kazmierski. Kazmierski then left, and Jules Casterman joined the firm. By 1916, Casterman was president of the Pittsburg Coca-Cola Bottling Company, and Adolph W. Schiefelbein was Lontkowsky's partner. By 1919, Schiefelbein left and John H. Kazmierski returned. This photograph was taken about 1920. (Courtesy of the Crawford County Historical Museum.)

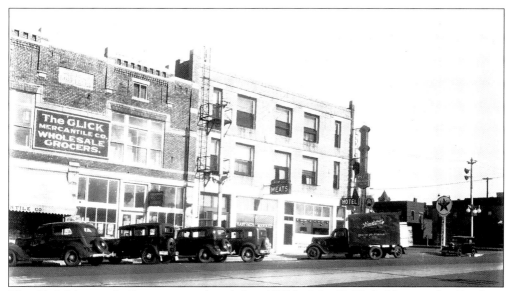

The Glick Mercantile Company was founded in 1907 by John F. Glick. He moved to Pittsburg from Topeka in 1900 to manage the grocery operation of the Standard Mercantile Company. Glick's business grew quickly enough that he had to move from his original location at Ninth Street and Broadway to Third Street and Broadway in 1913. The continued growth of the business required a second move in 1923 to the Robberson building at 113 North Broadway, seen in this photograph. One of the most popular products distributed by the Glick Mercantile Company was Golden Wedding coffee.

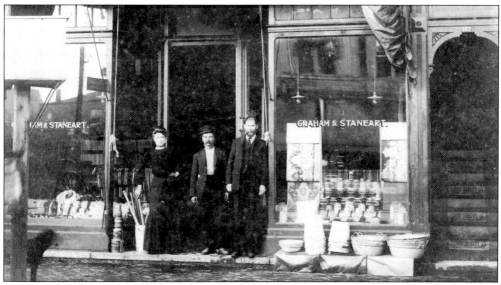

Blanche Martin, Archelus (Archie) A. Staneart, and James Alexander (right) pose in the doorway to the Graham and Staneart store at 503 North Broadway in 1905. Graham and Staneart was owned by Alexander E. Graham and Staneart, who were listed as booksellers and stationers. The business also carried a full line of wallpaper, paints, and painter's supplies. Graham was married to Inez Staneart in June 1903, shortly before the business opened. On June 2, 1906, the *Pittsburg Daily Headlight* ran this advertisement for Graham and Staneart: "Lease and fixtures sold; This store quits; Merchandise butchery commences next Monday, June 4th."

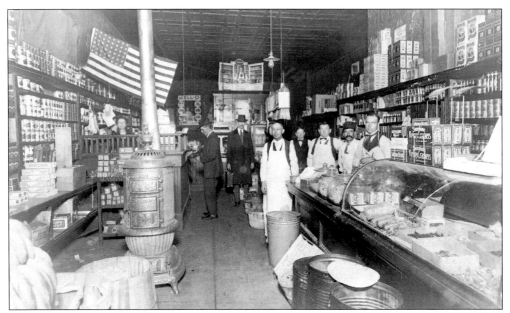

L. L. Hollinger established his grocery business in Pittsburg about 1890. He advertised his business as "a leading grocery and furnisher of good things to eat." Before commencing in the grocery business, Hollinger was a schoolteacher in the Pittsburg public schools for several years. Evident among the products Hollinger stocked in his grocery are Heinz ketchup, Jello, Hershey chocolates, and Sunshine crackers.

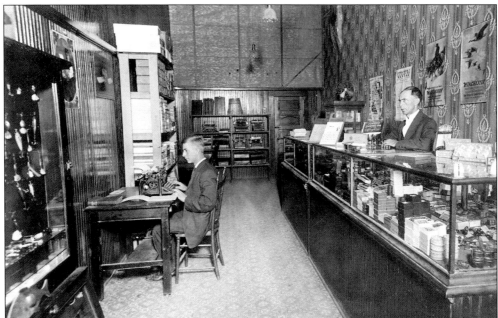

This photograph, taken at 506 North Broadway in 1920 or 1921, shows the inside of the Allen Typewriter and Office Supply Company. Ray B. Allen (right) was a public stenographer and notary public in Pittsburg for many years and also conducted his office supply business between the years 1905 and 1923. A display of antique fishing lures hangs to the left of the typist. Behind Allen is a broadside titled *Pittsburg, Kansas: The City With a $1,000,000 a Month Pay Roll*.

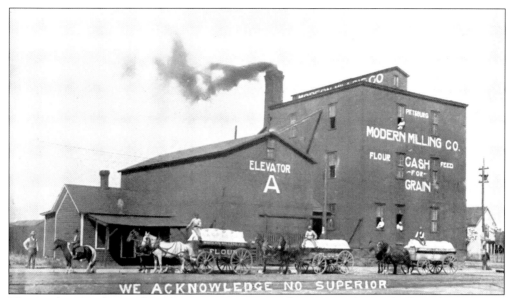

The Pittsburg Modern Milling Company was organized in 1898, replacing the firm of Jonathan R. McKim and Company that was in operation since 1889. In its first year of operations, the new company milled about 40,000 barrels of flour and almost an equal amount of cornmeal and livestock feed. The flour brands, known as Red Cross, Tiger Eye, King Cole, and Old Glory, were household staples throughout the four-state region. From this picture taken in 1911, many Pittsburg residents will recognize the facility at Fourth and Elm Streets by its later name of Kelso Seed and Grain Company. Part of this facility was burned during a severe fire in December 1939.

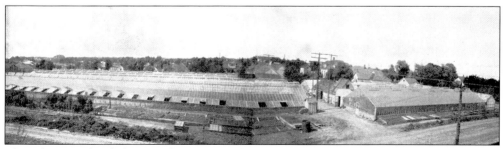

This photograph of the Steinhauser greenhouses was taken in 1915. Charles Steinhauser established his floral business about 1891 just outside Pittsburg. By 1900, it was the largest greenhouse operation in the region, with six greenhouses and 15 acres of flowers. Steinhauser located an office in Pittsburg at 418 North Broadway and sold his cut flowers, floral designs, and plants to all points within 100 miles of Pittsburg.

Thomas McNally came to the United States from Kildare, Ireland, in 1868 at the age of 16 and learned his trade of boilermaker in Grand Rapids, Michigan. In December 1889, he migrated to Pittsburg from Ashland, Wisconsin, and established the Pittsburg Boiler Works. The Pittsburg Commercial Club at that time was offering land and financial assistance to any industry that moved into the city. Thomas McNally Jr. took over the firm in 1906, and the company was incorporated in 1912. McNally Manufacturing grew into an international corporation that made it the number one manufacturer of coal-processing equipment in the world. Part of the Pittsburg facility is shown in this 1961 photograph.

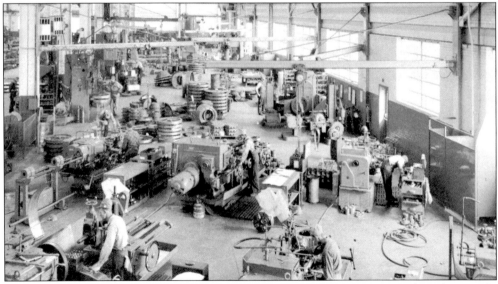

This photograph of the McNally Manufacturing Company operations was taken about 1957. When Thomas Jr. took over the Pittsburg Boiler and Machine Company from his father in 1906, the manufacture of coalfield equipment occupied all his attention. As coal production declined in the United States, he expanded the scope of operations to include the manufacture of tire molds, coke plant machinery, dredging equipment, oversize water valves for irrigation lines, dam gates, and dam gate hoists. Edward T. McNally succeeded his father as president in 1955. The company ended its operations in Pittsburg in 2002.

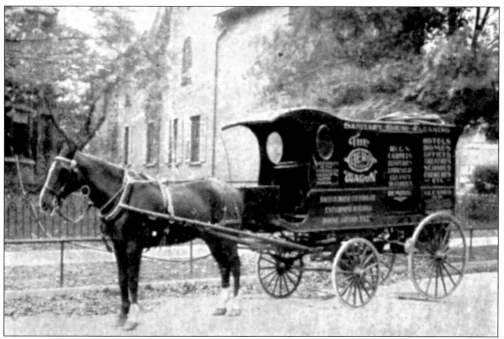

The Pittsburg Mattress Factory at Third and Locust Streets also offered Pittsburg residents and businesses sanitary housecleaning. Its Aero Wagon, seen in this 1909 photograph, advertised that it would clean hotels, homes, offices, theaters, schools, churches, and other facilities.

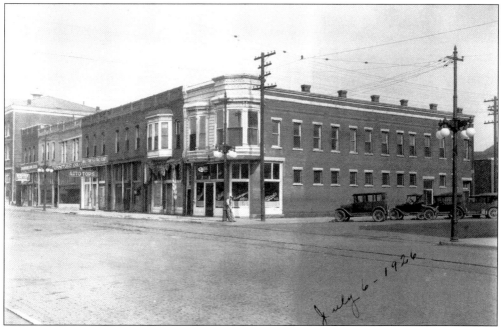

This photograph, taken on July 6, 1926, shows the northwest corner of Fourth and Locust Streets. The Anderson Block building and the other two-story buildings were relics of Pittsburg's earlier days. These buildings were torn down just days after this photograph was taken, and the Besse Hotel was erected on the site and opened in 1927.

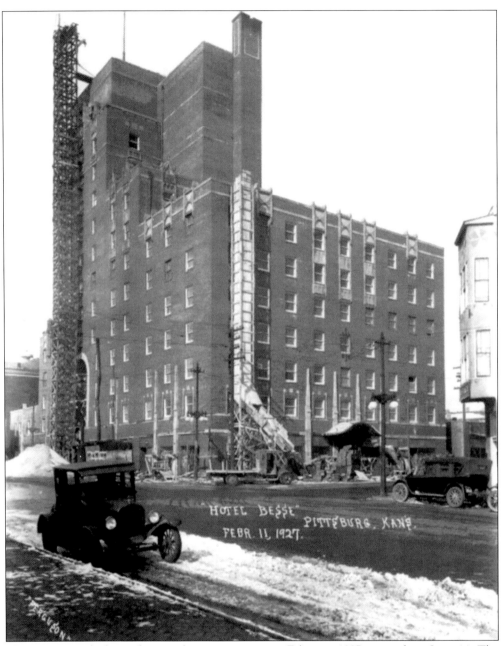

The Besse Hotel, shown here under construction in February 1927, opened on June 14. The 14-story hotel still dominates the Pittsburg skyline today. Alexander Besse, for whom the hotel is named, immigrated to the United States from France at the age of 12. He arrived in Pittsburg when he was 14 and survived by peddling lamp wicks and shoestrings on the city's streets. He earned enough money in time to open a store where he sold sewing machines, organs, and pianos. After 1913, Besse was primarily involved in real estate, the Besse-Cockerill Coal Company, and the Pittsburg Amusement Company that managed the Fox and Midland Theaters. In 1926, Besse mortgaged most of his properties to get $30,000 to invest in the construction of the hotel.

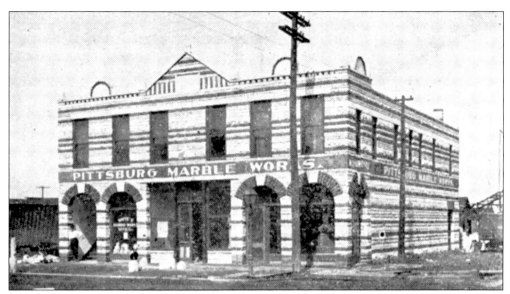

On the corner of Second and Locust Streets stands one of the outstanding examples of folk architecture in the state. The two-story stone building, corniced with carved fans and torches, contains within the arches over each window sculptured portraits of American folk heroes Christopher Columbus, George Washington, Mark Twain, Belle Starr, and others. The designer was Hance White, a stonemason and monument builder, who came to Pittsburg in 1891 and purchased the existing Pittsburg Marble Works firm. This photograph of the White business was taken in 1909. Marble and granite arrived from quarries around the world and were unloaded by huge derricks at the nearby Frisco railroad depot. Four traveling salesmen covered a large territory for the firm and erected some of the finest works to be found in the cemeteries of Kansas, Missouri, and Oklahoma.

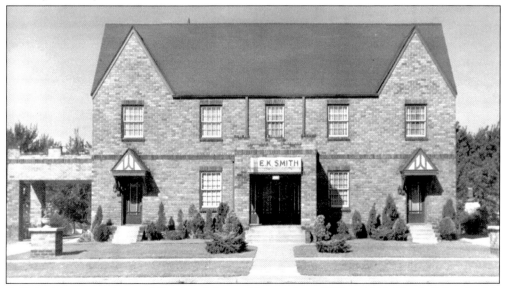

E. K. Smith operated one of Pittsburg's funeral homes from 1916 to 1945. The building in this photograph was constructed at 510 South Broadway after a few years of operation. In 1945, Smith sold the home and his business interests to Thomas W. Bath and Sim P. Wesonig. The business kept the Smith name until 1951.

Thomas Jackson Crowell, named after Thomas Jonathan "Stonewall" Jackson, under whom his father fought for the Confederacy, was born in 1863 in Albemarle, North Carolina. His family migrated to Pittsburg in 1876. Crowell studied pharmaceuticals at the state normal college in Fort Scott and upon graduation moved to Harper to work as an accountant for his brothers in the lumber business. Crowell returned to Pittsburg in 1890 to open a drugstore on the corner of Fourth Street and Broadway. In 1915, he expanded his business by purchasing the Ash Drug Store. He was active in chamber of commerce and civic events. He was a leader of the Democratic Party in the state of Kansas and became a personal friend of Pres. Franklin Roosevelt. Crowell retired in 1937, turning over the business to his son Paul.

Businessman and philanthropist O. Gene Bicknell earned two degrees from Pittsburg State University and has been honored by the university with its Meritorious Achievement Award, Leadership Service Award, and many other distinctions. In the early 1960s, with the purchase of his first Pizza Hut, Bicknell began to build the largest single Pizza Hut franchise in the country. He has served as chairman of numerous corporations, including Pitt Plastics and the National Pizza Corporation. Bicknell has been a major benefactor of the city and the university through the Gene Bicknell Sports Complex that opened in 1995, the Kansas Technology Center that opened in 1997, and other projects.

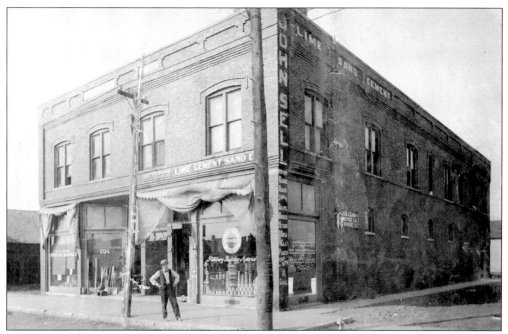

John Sell stands in front of his Pittsburg Building Material and Peacock Coal Company building at 204 North Broadway around 1908. Sell's company provided most of the materials used in the construction of the Pittsburg Public Library, the Commercial Building, and the original pillars that graced the entrance to Lincoln Park.

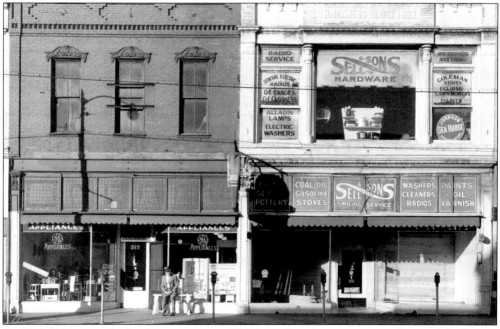

In 1913, Sell opened a hardware store at 319 North Broadway in partnership with J. George Atkins. In 1923, the name of the firm became Sell and Sons. This photograph of the business taken in the late 1940s shows that Sell continued to believe in advertising, a trait he developed when working for the hardware firm of Beasley and Miller as a young man.

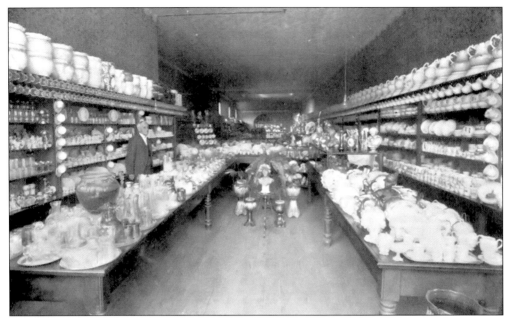

This photograph, taken in 1902, shows William C. Peck who operated the Peck Queensware Company at 319 North Broadway. Peck was an agent for the Greensburg Glass Company of Greensburg, Pennsylvania; the Potters Cooperative Company of East Liverpool, England; and the Bonita Glass Company of Cicero, Indiana. Peck also carried a full line of stoneware, hotel ware, lamps, Rockingham china, and Haviland china.

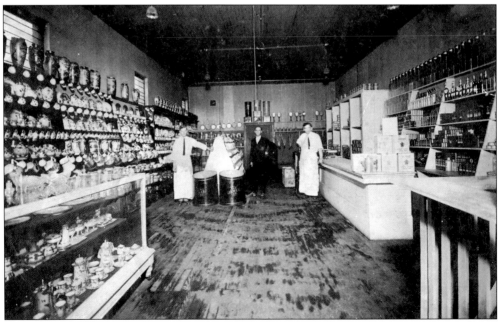

The Jewel Tea Company at 113 North Joplin Street was founded in 1911. They handled a full line of teas, coffees, spices, extracts, and laundry and toiletry articles. In 1926, the company claimed to provide home delivery of these products to 7,000 families in Pittsburg and the immediate area. Their sales territory was significant, extending as far as Anderson, Coffey, and Wilson Counties.

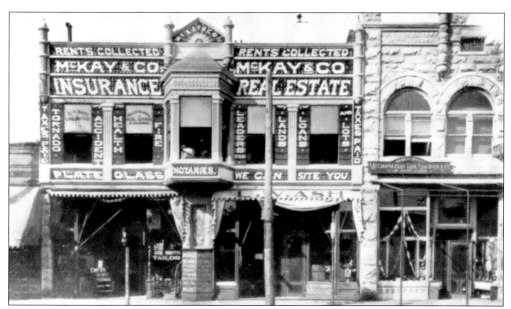

McKay and Company made a specialty of handling Pittsburg real estate, rentals, and fire and accident insurance. Frank McKay Sr. was a pioneer in Pittsburg, arriving in 1878. Other offices in the McKay building at 419 North Broadway on the lower level included Joe Smith, a tailor, and the Ash Drug Store operated by Louis W. Ash. The building to the right was the First National Bank building and a branch office of the Metropolitan Life Insurance Company of New York.

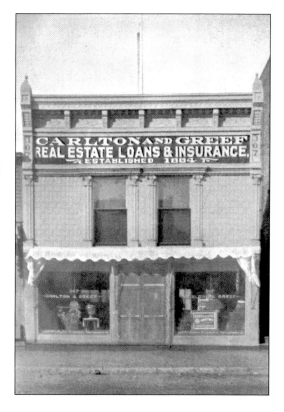

The Carlton and Greef Real Estate, Loan, and Insurance Company, established in 1884 at 307 North Broadway, was one of the earliest insurance providers in Pittsburg. In 1899, it became the oldest real estate firm in the city. Robert E. Carlton was one of the first settlers of Crawford County and served as county clerk for eight years before opening his real estate business in Pittsburg. Carlton's daughter Minnie Carlton True became Pittsburg's first female postmaster. Albert H. Greef was connected with D. J. Dean in the management of the Hotel Stilwell for a period and was an officer of the Pittsburg Commercial Club. Greef was also secretary of the Kansas Commission of the Trans-Mississippi Exposition. This photograph of the company building was taken in 1901.

John A. Gibson was president of the Standard Ice and Fuel Company, founded in 1904. This photograph of plant No. 1 was taken in 1909 at Second and Pine Streets. Plant No. 2 was constructed at Sixth and Locust Streets in 1910. Together the plants could produce 140 tons of ice per day and store nearly 9,000 tons. Thousands of fruit and produce railroad cars were re-iced by the Standard Company during the season. In 1926, there were 11 familiar yellow wagons and five yellow trucks that delivered ice from the company to stores and homes in the region.

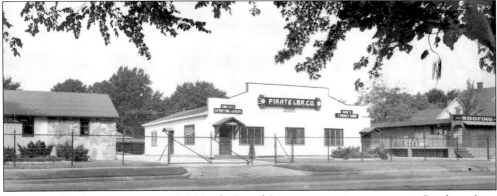

The Pirate Lumber Company at 1603 North Grand Street was a going concern in Pittsburg from 1936 to 1959. Raymond C. Smith and Quincy Mingori were owners of the well-known lumber company. Smith's Sporting Goods continued to operate at this address after the lumberyard closed. (Courtesy of the Crawford County Historical Museum.)

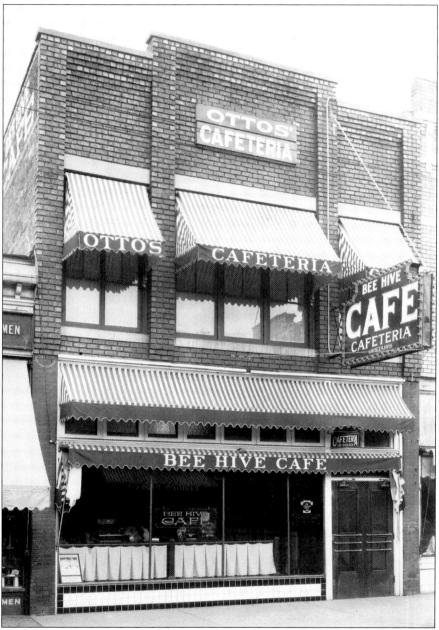

The Otto name has been synonymous with food service in Pittsburg for more than eight decades. Gus and Nels Otto entered the cafeteria business in Pittsburg in 1922 in partnership with Bert Bussey at the Bee Hive Café. When the partnership dissolved, Bussey took the cafeteria as his share but soon sold it to Jessie Cochran. After a fire, Cochran sold the cafeteria back to the Otto brothers in 1925. In April 1927, the Otto Brothers cafeteria opened for business in its new location at 514 North Broadway, above the Bee Hive Café. Cooking for both the café and the cafeteria was done in the kitchen on the first floor. A dumbwaiter was installed to hoist the food from the kitchen to the cafeteria. Women chefs headed a staff of 38 employees that operated the two facilities. The Bee Hive was open 24 hours each day, while the cafeteria was open from 10:00 a.m. to 2:00 p.m. and from 5:00 p.m. until 7:30 p.m.

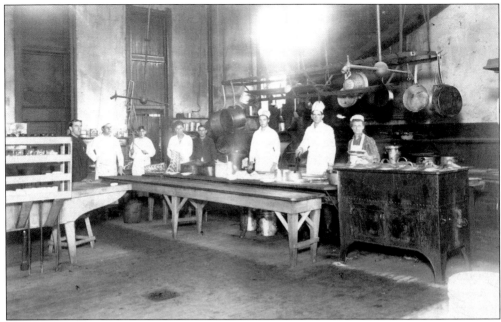

This is where the meals were prepared in the early days of the Hotel Stilwell. Eight members of the kitchen staff are seen in this photograph taken about 1915. The staff was kept busy preparing meals for the hotel guests and visiting dignitaries. From 1889 through the 1950s, local organizations hosted their banquets at the Stilwell as a matter of course.

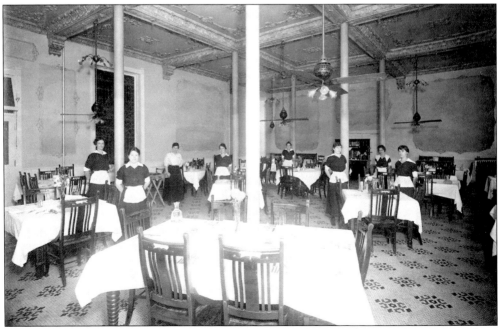

In this photograph, the waitstaff of the Hotel Stilwell is gathered in the main dining room about 1920. The architects hired to design the Stilwell in 1889 were J. B. Lindsley and Son of St. Louis, a firm that specialized in hotels and public buildings. Lindsley's plans called for a late Victorian mixture of Italian Renaissance and Romanesque design.

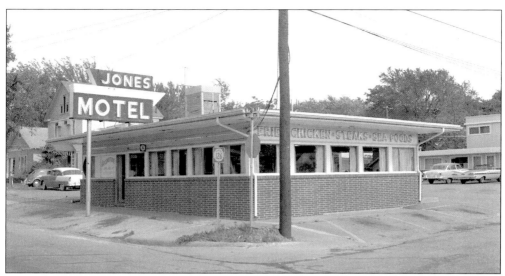

In 1946, Leon and Emily Jones were looking to open up a business in Pittsburg. Their business began as a filling station but was quickly renovated into a restaurant. The restaurant was popular with students from the college and was usually packed at night, being the only eating establishment in Pittsburg during that era that stayed open until 2:00 a.m. The restaurant was severely damaged by a fire in the late 1950s. When it was reconstructed, the Joneses added a 32-room motel with a swimming pool, banquet room, and clubhouse. This image was taken in June 1961. The business became a Pittsburg landmark on West Fourth Street but was demolished in 2007 to make way for a new Pittsburg fire station.

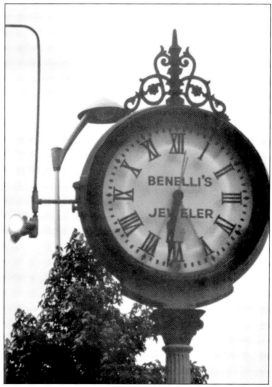

The Benelli Jewelry Store clock was long a fixture of downtown Pittsburg. The Seth Thomas clock weighed more than two tons and featured a jeweled movement in its base. The Benelli business began in Frontenac in 1902 and moved to Pittsburg in September 1917. D. P. Benelli purchased the clock from George Killam, another jeweler, in 1920. At that time, the clock was located at 217 North Broadway. Just over a year later, Benelli moved his firm and the clock to 311 North Broadway. Benelli was in business with his sons Andrew and Charles for many years. A third son, Martin, opened his own jewelry business at 720 North Broadway.

One of Pittsburg's leading mercantile houses was established in 1890 by the Ramsay brothers. They also conducted stores in Iola; Carthage, Missouri; and Guthrie and Muskogee, Oklahoma. Robert Ramsay had charge of the Pittsburg store for many years and stocked a complete line of dry goods and household furnishings. This photograph shows how the store at 602 North Broadway appeared in September 1951 when Pittsburg was 75 years old.

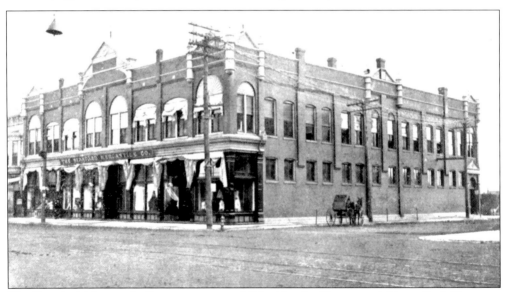

The Standard Mercantile Company was established by the Kansas and Texas Coal Company and the Wear Coal Company, but ownership soon passed into private hands in April 1899. Archibald B. Kirkwood was president of the Standard, said to be the largest department store in Kansas at the time this photograph was taken in 1900. The Standard employed more than 40 clerks. Household furnishings, shoes, crockery, hardware, groceries, carpets, and many other products were available under one roof at 619–625 North Broadway.

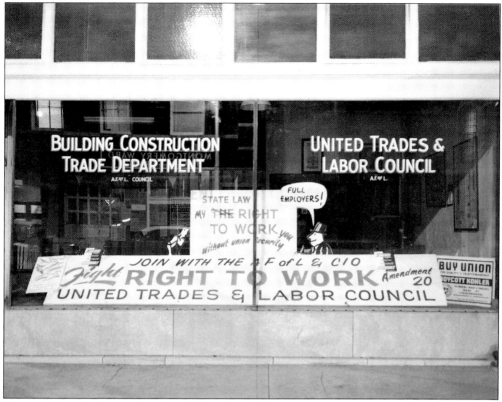

This window display in October 1959 reflected the ongoing importance of labor unions in Pittsburg for many years after the city was heavily industrialized and unionized. The display, prepared by members of the American Federation of Labor-Congress of Industrial Organizations (AFL-CIO) local, was next door to the Labor Temple on West Fifth Street.

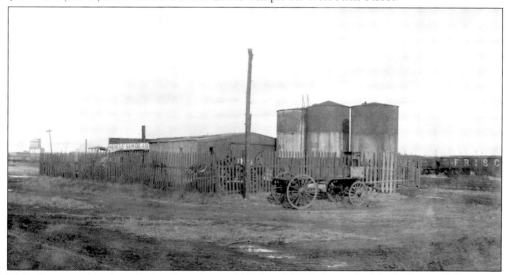

This photograph, taken during the winter of 1916 and 1917, shows the Uncle Sam Oil Company facilities on South Joplin Street. The tall buildings on the left are the Kelso Grain and Seed Company located at Fourth and Elm Streets. (Courtesy of Brenda and Robert Mishmash.)

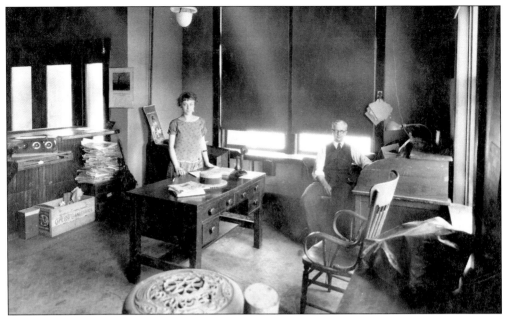

Henry G. Nation and his bookkeeper, Loretta Fisher, pose for this photograph in 1925 in the offices of the Nation Fruit Company at 1217 North Broadway. Fisher was probably a graduate of the Pittsburg Business College, being listed as a student in the 1919 directory. Nation was a longtime businessman in Pittsburg and in 1919 was elected president of the Pittsburg Chamber of Commerce. Nation worked extensively for good roads projects in southeast Kansas.

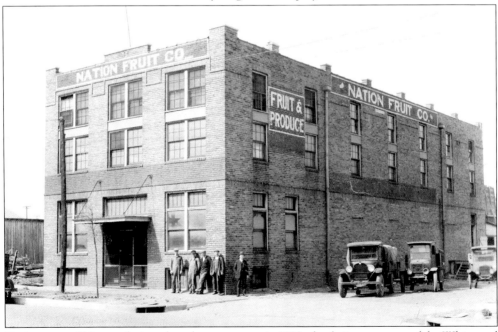

Nation opened his own fruit and produce company in 1922 after being manager of the White and Allen Fruit Company for some years. By 1932, he was a salesman for the Kelso Seed Company. This photograph of the Nation Fruit Company building and employees was taken by Ferguson's Studio about 1925. This building was later occupied by Puritan Dairy Products Company.

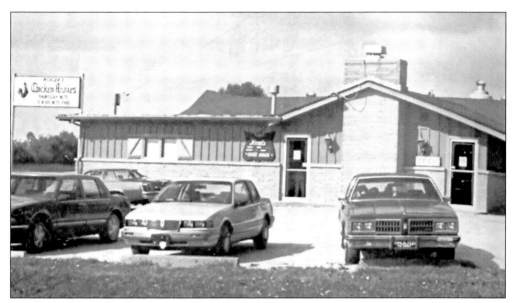

Southeast Kansas has been famous for its fried chicken restaurants since the era of World War II. Chicken Mary's in Yale; Barto's in Frontenac; Gebhardt's in rural Mulberry; and Chicken Annie's in Yale, Girard, and Pittsburg are all still heavily patronized restaurants at this time. This photograph of Pichler's Chicken Annie's on Langdon Lane in Pittsburg was taken in 1989.

Everyone familiar with Pittsburg's history is familiar with the A. J. Cripe Bakery and its Town Talk bread. Cripe arrived in Pittsburg in 1935 and started his bakery that served an area from Pleasanton, Kansas, to Afton, Oklahoma, and from Independence, Kansas, to Golden City, Missouri. This image of the Cripe Bakery at 112 East Rose Street shows how it appeared in the 1940s.

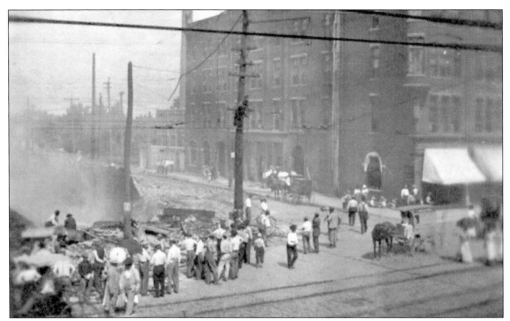

The intersection of Seventh Street and Broadway has been the site of several devastating fires in Pittsburg's history. In this photograph taken in 1911, a crowd gathers as cleanup begins after the S. H. Kress and Company store burned. To the right is the Hotel Stilwell. The Kress store rebuilt but suffered a second extensive fire at this location in early 1917. The store rebuilt and opened again on March 31, 1917.

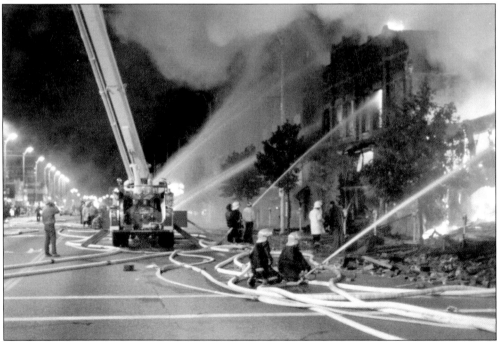

The Moore's Furniture Company was located at Seventh Street and Broadway for many years until this fire in 1977. Members of the Pittsburg Fire Department battled this fire through the evening. (Courtesy of Brenda and Robert Mishmash.)

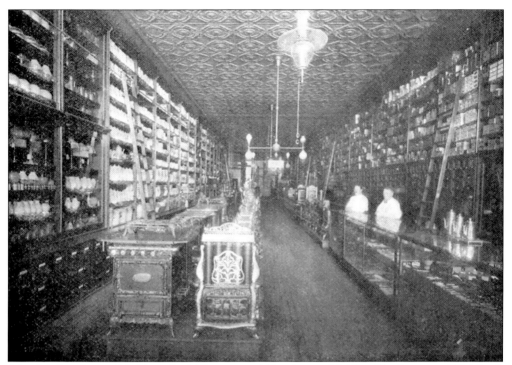

John H. Beasley and Melvin D. Miller opened Beasley and Miller Hardware at 507 North Broadway about 1895. In 1910, they built a store at 610 North Broadway, and this photograph of their store was taken around 1911. In 1930, Beasley sold his partnership in the hardware store and opened the Beasley Plumbing and Heating Company, which he ran until 1949. Beasley first came to Pittsburg in 1889. He helped organize the First State Bank and Trust Company and served on the Girl Scout board for many years. He was one of the last of Pittsburg's early merchants to remain active in Pittsburg, operating a business for over 60 years.

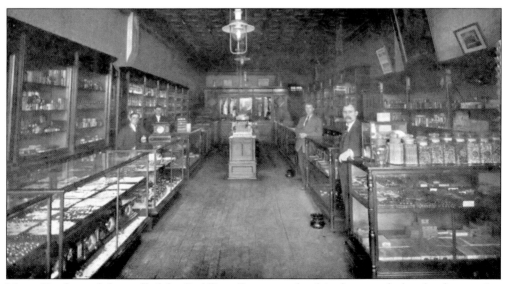

Henry Kettler and the staff of the Owl Drug Store pose for this photograph shortly after moving into their new location at 316 North Broadway in 1906.

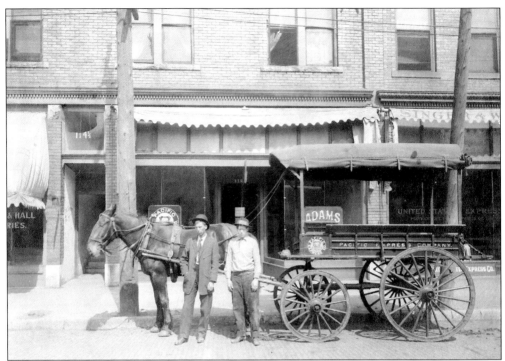

Jacob E. (left) and Amos B. Foote, agent and cashier, respectively, for the Adams Express, Pacific Express, and United States Express Companies, pose with their delivery wagon around 1910. The offices of the three express companies were located at 112 West Fourth Street.

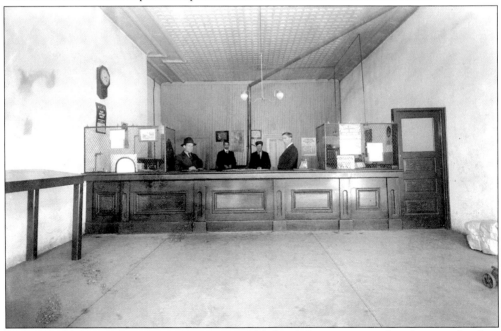

Employees of the Pacific Express Company stand behind the counter in this photograph taken in February 1909. Jacob E. Foote was the agent for the Adams Express Company and the Pacific Express Company when this image was taken. Amos B. Foote was the cashier for both firms.

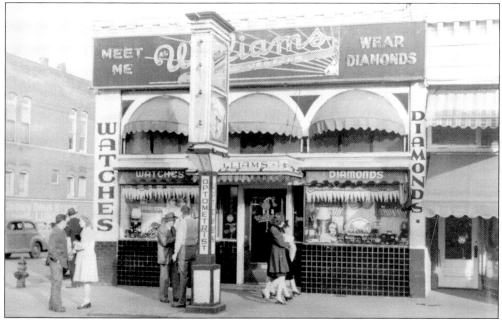

The first jewelry store in Pittsburg was established by J. H. Chapman in 1887. In 1892, James U. Treadwell became a junior partner and eventually the sole proprietor when Chapman sold his interest and opened a battery station at 310 East Seventh Street. The jewelry store was located inside the drugstore of Louis W. Ash. Al Williams joined the staff in 1905 and later became a partner with Treadwell. Williams purchased full control of the business in 1912 but kept the Treadwell name until 1920. In May 1930, Williams moved his store to this location at 424 North Broadway. Tragedy struck the Williams family in January 1948, not long after this photograph was taken, when three thieves entered the store at closing time and killed the Williamses' youngest son, Gene, during a robbery.

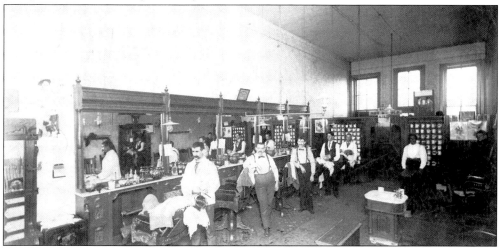

Evidence suggests this may be a photograph of the Coughenour and Pogson barbershop and bathrooms taken about 1900. Weyland D. Coughenour and George W. Pogson operated such an establishment at 109 East Fourth Street. The city directories indicate Coughenour left this business a few years later, but Pogson ran one of Pittsburg's best barbershops in the National Bank building for many more years.

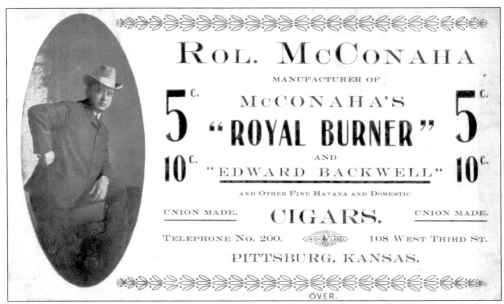

Rolla A. McConaha lived from 1875 to 1947. By 1900, he was a cigar manufacturer in Pittsburg, a profession that he continued for 40 years. In the last years of his life, he worked as a salesman. This advertising card appeared about 1905 when he moved his operation from Fourth Street to 108 West Third Street.

Otto's Café has been a popular fixture on Broadway in downtown Pittsburg since 1945. It was built by Nels Otto as an annex to the Hotel Stilwell after Otto was associated with the Bee Hive Café and the Otto Brothers Cafeteria for many years. In 1945, Otto sold the new café to Frank and Marian Johnson, who operated the café for many years. Otto's still features home-style cooking and fresh-baked pastries. This photograph was taken about 1950.

Five

HEAD, HAND, AND HEART

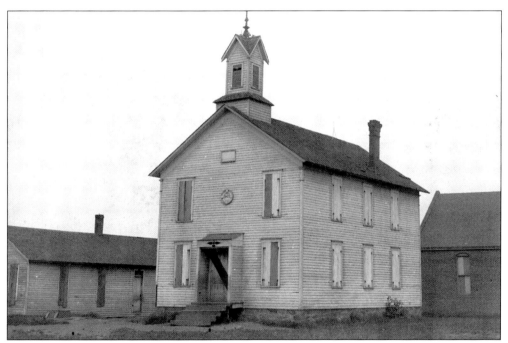

The first school building constructed in Pittsburg stood on the northwest corner of Walnut and Fifth Streets. This photograph was taken in 1887, 10 years after the school was built. The building cost $1,200 and was a simple structure with one room on each floor. It was moved to the southeast corner of Third and Pine Streets in 1893 to allow for the construction of Central High School. This building was converted into a boardinghouse and was used as the city hospital for a short time.

At the close of the Civil War, Augustus J. Georgia settled on a claim near the present site of Pittsburg and became the first schoolteacher in the area. In January 1877, he was elected superintendent of schools for Crawford County, and his first action was to establish the Pittsburg city school district. Georgia also served as postmaster in Pittsburg, helped organize the Pittsburg Board of Trade, and ran a real estate office.

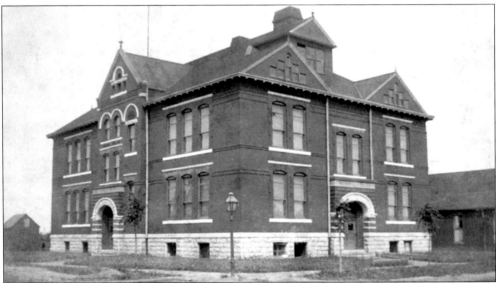

This photograph shows the Central School building in 1895. It was originally built to be the high school in Pittsburg in 1893. In 1903, the Pittsburg Board of Education loaned the building to the state of Kansas to be used as the first home of the Kansas State Manual Training Normal School, now known as Pittsburg State University. The training normal school left in December 1908 to move into Russ Hall on the present university campus. The size of the Central School was doubled in 1926 to meet the needs of the city's elementary students. The students who attended Central were transferred to the new Westside building when it was constructed in 1951.

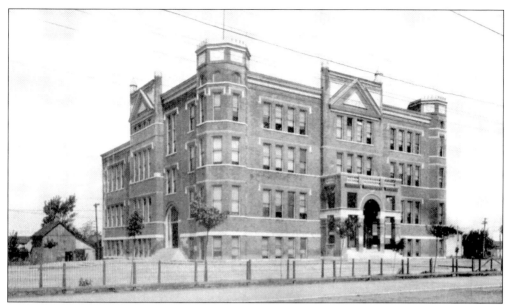

Russell S. Russ, who became the founder and first head of what is now Pittsburg State University, first came to Pittsburg as superintendent of the public schools in 1897. In addition to the traditional work, Russ introduced manual training for boys and domestic science for girls into the high school curriculum. Russ believed this expanded curriculum would have a positive impact on training the heads, hands, and hearts of young people. This high school building on the northwest corner of Eighth Street and Broadway was often called Manual Training High School. It was completed in 1903. It became a junior high school when another modern high school was built in 1921.

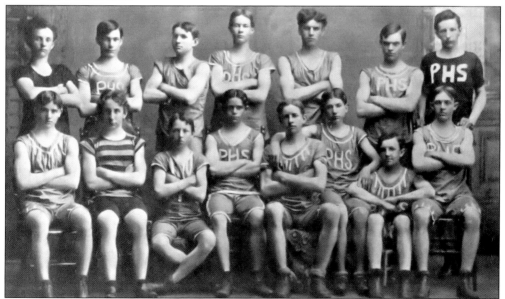

This photograph of the Pittsburg High School track team was taken in 1902. From left to right, the athletes are identified as (first row) ? Ralston, Robert Duncan, Edward Raber, James Billings, Clayton Parker, ? Wood, Maurice Widby, and R. Taylor; (second row) W. Williamson, J. Parker, Leo McNally, L. Parker, ? Cronister, ? Kerley, and Arthur Williamson.

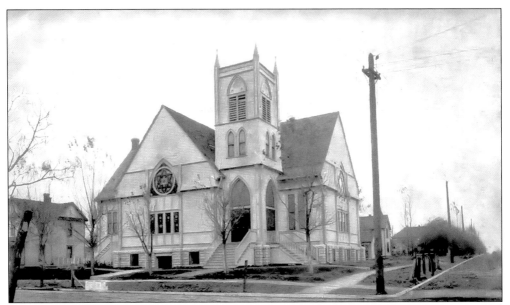

The First Baptist Church was the first chartered religious body in Pittsburg. It was organized under the name of the Eden Church with nine members, before Pittsburg existed, on August 3, 1872. Their first church in Pittsburg was a small brick structure at Sixth and Walnut Streets. This building was sold, and the members met in the YMCA for a time. In 1895, work was started on the building at Seventh and Walnut Streets, seen in this photograph. In 1907, the building was remodeled and enlarged. In 1924, it was covered with brick veneer and remodeled again.

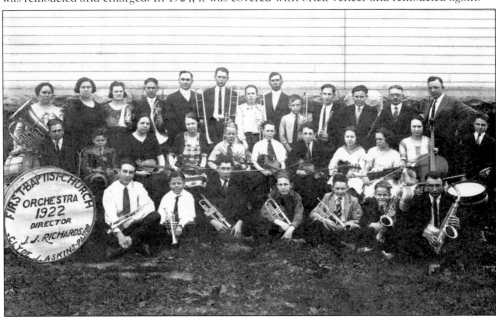

John J. Richards (standing, second from right) directed the orchestra of the First Baptist Church in 1922 when this photograph was taken. Richards was born in Wales in 1878 but spent most of his youth in the coal camp of Yale. While he lived in Pittsburg, Richards taught instrumental music at Pittsburg High School, operated a music store, and directed the municipal band and the Mirza Shrine Band. (Courtesy of the Crawford County Historical Museum.)

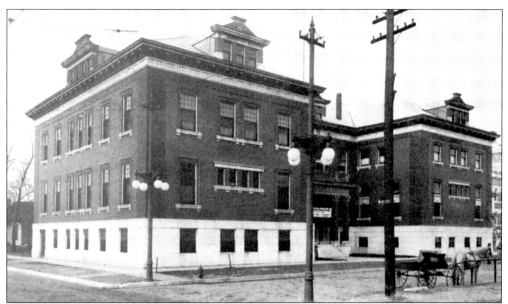

The Pittsburg YMCA was organized in 1887 and held its Christian fellowship and recreational meetings in the Commercial Club rooms at 303 North Broadway. This three-floor building was opened in early 1910 following an extensive community subscription drive. The new building, located at Fourth and Pine Streets, hosted the Pittsburg High School basketball games until 1921, provided quarters for the opening of a Teen Town organization during World War II, and hosted many other community events through the years.

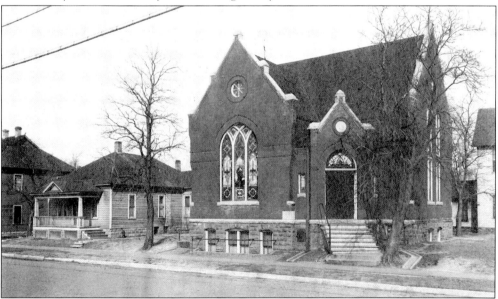

The Evangelical United Brethren Church was built in 1892 at 405 South Locust Street. Beginning in 1910, the small structure underwent additions and interior remodeling, and a brick veneer was added. This photograph was taken about 1915. The congregation reached a high point in membership in the 1920s. The building was sold to the Church of Jesus Christ of Latter Day Saints when the Evangelical United Brethren and the Methodist Churches merged to become United Methodists.

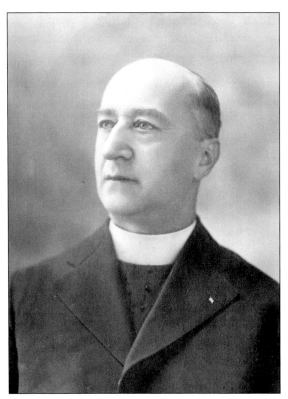

Joseph August Pompeney came to St. Mary's Church in Pittsburg in 1893 after spending 13 years in various colleges and universities and receiving four advanced degrees. Pompeney served the Pittsburg community until 1897. He was the founder of the Academic Library Club that provided the impetus to start a city library. In 1904, Pompeney was appointed to serve the Catholic Church in Frontenac. In 1912, he was reappointed to St. Mary's in Pittsburg, serving until 1928. During World War I, Pompeney served as sergeant and chaplain in the Kansas State Guard. In 1928, he was transferred to Newton, where he passed away in 1940.

Ella Buchanan became the first public librarian in Pittsburg in December 1901. Buchanan, born in Preston, Canada, came to Pittsburg in 1898 to work as a solicitor for the *Pittsburg Kansan*, a Democratic newspaper founded by her father. She served as the librarian for seven years before a disagreement arose between her and the lawyer, Morris Cliggitt, who was president of the library board. Buchanan resigned her position in the library in 1908 and joined her sister at the Chicago Art Institute. Buchanan became a noted sculptor and in 1940 received the Eleanor Roosevelt Award for distinguished achievement by a woman. She lived to see her name listed in the *American Art Annual*, the *Dictionary of American Painters, Sculptors, and Engravers*, and *Who's Who in America*.

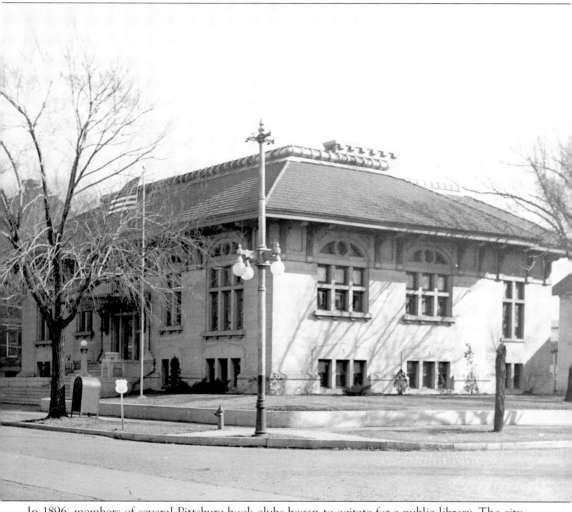

In 1896, members of several Pittsburg book clubs began to agitate for a public library. The city approved a small tax levy for library purposes two years later. Members of the appointed library board used the levy for several years to buy books and equipment. When the library opened in January 1902 in the west room of city hall's first floor, 1,601 books were available. In 1909, the city approached philanthropist Andrew Carnegie, who was helping to set up public libraries all across the United States. Carnegie offered $40,000, which was accepted, and the cornerstone of the new library was laid on September 10, 1910. Local miners and labor leaders opposed the gift, recalling Carnegie's treatment of his workers during a strike at his Homestead, Pennsylvania, steel plant in 1892. In deference to local feelings, the library was not built in the typical Carnegie architectural style, and the words over the entrance simply say "Public Library." It is believed that the Pittsburg Public Library is the only Carnegie library in the nation on which Carnegie's name is nowhere attached. This photograph of the library at Fourth and Walnut Streets was taken about 1951.

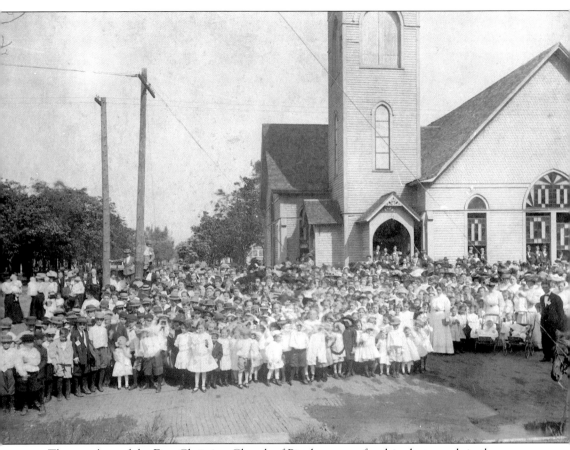

The members of the First Christian Church of Pittsburg pose for this photograph in the summer of 1901. Standing at right next to the baby carriages is the pastor of the church, Harold Bell Wright. Pittsburg was the second pastorate of Wright, an inspirational novelist who became the first bestselling author in America and the first writer to become a millionaire as a result of his publications. Wright's pastorate in Pittsburg started in 1898. In his autobiography, Wright noted, "the population of Pittsburg was about fifteen thousand. It was in the heart of a coal-mining district and a railroad center, with extensive railroad shops. There were fourteen denominational churches and not a place except saloons, gambling houses, and houses of prostitution where a man might spend a leisure hour." Wright wanted to capture his congregation's attention, so he wrote a moralistic tale of intrigue, mystery, romance, murder, and betrayal. When it was completed, Wright called this first novel *That Printer of Udell's*. Several of the central characters in the novel were based on Pittsburg personalities to further strike a chord with the congregation. The Book Supply Company of Chicago printed Wright's story in May 1903, launching his successful literary career.

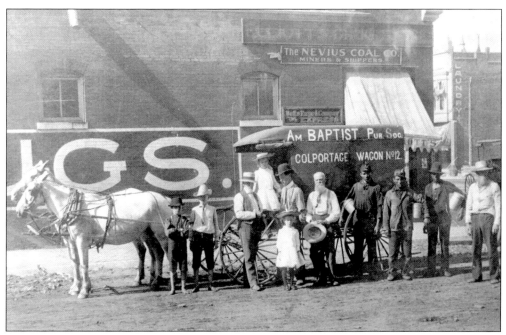

Coal miners and other Pittsburg residents pause for this photograph in the early 1900s before receiving Bibles and religious tracts from the American Baptist Publications Society. The society's colportage wagon No. 12 is parked in front of Elliott's Drug Store at Broadway and Sixth Street. (Courtesy of the Crawford County Historical Museum.)

In 1893, the Kansas State Baptist Convention sent a militant Women's Christian Temperance Union lecturer to Pittsburg to bolster the lagging membership in the First Baptist Church. Edith Hill led a five-week revival that caused the membership of the church to rise from 93 to 233. The church was so impressed with Hill that they offered her their open pastorate. She accepted on the condition that the church would ordain her. Accordingly, on April 13, 1894, Hill became the second woman ever in the world to be ordained by the Baptist denomination.

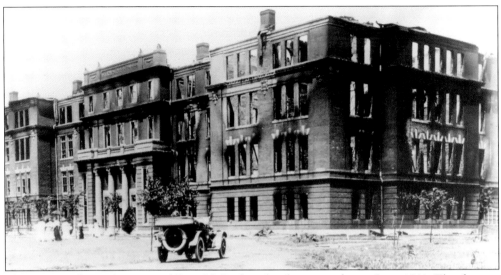

This picture shows the ruins of Russ Hall after the disastrous fire in June 1914. The fire, set by a bolt of lightning, gutted the building, leaving only the bare walls standing. Russ Hall was the primary administration and classroom building on the campus of the State Manual Training Normal School (SMTN), now Pittsburg State University. The loss of the building and equipment renewed the political agitation across the state to discontinue the SMTN. In less than one week, Pittsburg residents and businesses pledged $150,000 to assure the rebuilding of the hall. The building was reopened in the fall of 1915, and the state legislature appropriated the money to repay the pledged funds.

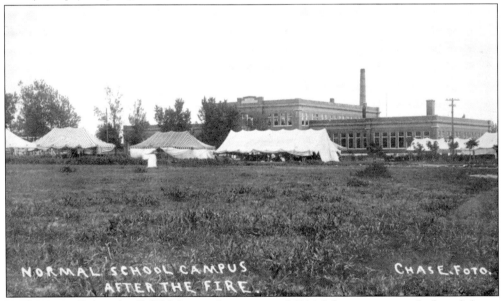

Students enrolled in the SMTN during the summer of 1914 did not miss a single day of classes after a fire destroyed Russ Hall. The industrial arts building, seen in the background of this photograph taken just after the fire, was the only building left on campus. Classes were transferred from Russ Hall to buildings in downtown Pittsburg and to tents set up on the campus oval. President William Aaron Brandenburg noted that not one student withdrew from the SMTN after the fire.

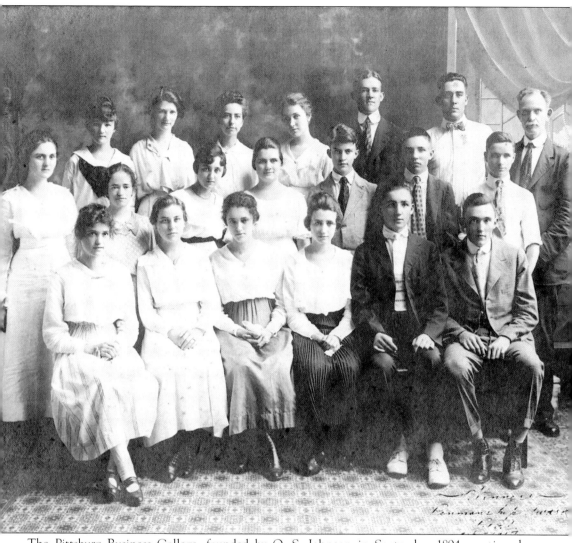

The Pittsburg Business College, founded by O. S. Johnson in September 1894, continued through 1946. Pierce W. Errebo joined the faculty in 1901 and bought out Johnson's interests in 1903. Enrollment increased to over 125, and the school moved to larger quarters on several occasions until it erected its own building at Broadway and Kansas Street in 1918. The business school occupied the top two floors of the building, and the lower level was home to the affiliated Central Automobile and Tractor School. The annual enrollment grew to 500 students in 1925. Students took classes in shorthand, typing, penmanship, spelling, business correspondence, and similar courses. This photograph, taken in 1917, shows the winners of the school's annual penmanship award.

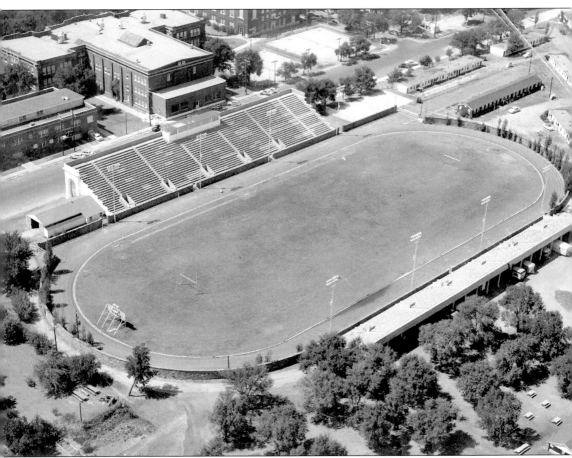

This aerial view of the Kansas State Teachers College campus, now Pittsburg State University, was taken in 1955. The athletic facilities were originally known as Brandenburg Field and Stadium when they were completed in 1924 and named in honor of president William Aaron Brandenburg. The stone wall surrounding the field was a project of Civilian Conservation Corps camp workers during the 1930s and is made from native stone quarried north of Pittsburg. The concrete bleachers on the east side of the stadium were built by the Works Progress Administration. The first major renovations were completed in 1989, and the facility was rededicated the Carnie Smith Stadium, Brandenburg Field, and the Prentice Gudgen Jr. track. An addition to the east-side bleachers was completed in 2001, and a second addition to the west-side bleachers was finished in 2006. The large building to the left of the stadium is Carney Hall and Auditorium that stood from 1919 to 1980. Just to the right of Carney Hall is the original gymnasium that was torn down in 1972. The small buildings to the right of the stadium were barracks from World War II being used as student housing in 1955. During the war, the barracks were occupied by U.S. Navy V-12 program students stationed on the campus.

This photograph of the United Presbyterian Church of Pittsburg was taken about 1950. The church was founded on April 29, 1890. This building at Fourth and Walnut Streets was dedicated on May 21, 1916, but it no longer survives.

St. Peter's Episcopal Church traces its history back to 1881. Members of the denomination met in homes about the community until a building was constructed at Seventh and Elm Streets in September 1882. Work on the church seen in this early photograph began in 1890 at 306 West Euclid Avenue but was not completed for nearly four years.

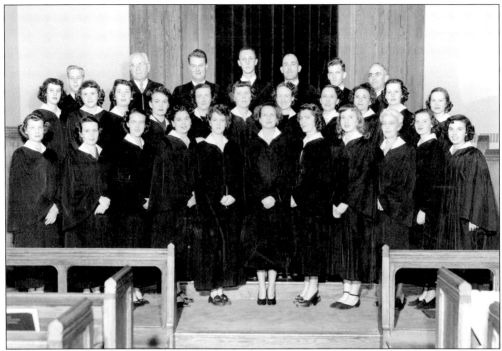

This photograph of the choir of the First Methodist Church was taken about 1950. Many of the choir members were well-known residents of Pittsburg at the time, including Martha Pate (front row, center), a pianist and music teacher; Helen Kelso Carney (second row, fifth from right), a teacher of French at Pittsburg State University and in the Tulsa, Oklahoma, public schools; and Samuel J. Pease (back row, second from left), chairman of the Department of Foreign Languages at Pittsburg State University for many years.

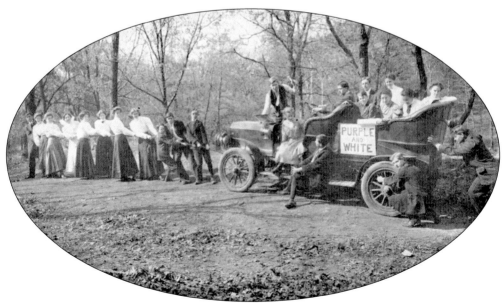

This photograph of students from Pittsburg High School in 1909 appeared in *The Purple and White*, the student yearbook.

Six

DIVERSIONS AND OTHER ENTERTAINMENTS

This photograph of the Steinway Four was taken in 1924. From left to right, the members are Sammy Tucker, tenor; Jack Turner, lead singer; Harry Gmeiner, bass; and Frank Dodson, baritone. Gmeiner was a machinist for the Kansas City Southern Railway. Dodson was a window decorator for the Globe Clothing and Shoe Company. No information about Tucker is available, and Turner may have been a miner.

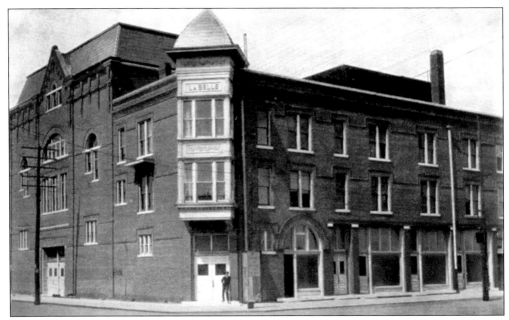

The LaBelle Theater opened in May 1904. It was more generally known as the opera house, even after its name was officially changed to the Orpheum Theater. LaBelle hosted many of Pittsburg's outstanding vaudeville attractions and home talent shows. The theater was burned to the ground in November 1915, but after several years, the building was reconstructed and converted into the Elizabeth apartments.

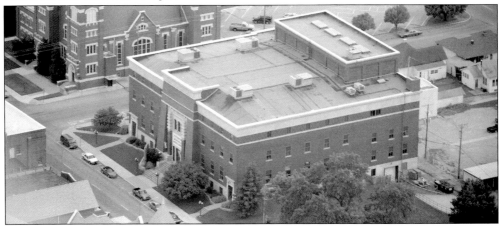

Pittsburg's Memorial Auditorium was formerly the temple of Mirza Shrine. In 1915, John Hodges, president of the Pittsburg and Midway Coal Company, left most of his estate for the purpose of building a shrine temple in Pittsburg. Construction began in 1923 and was completed in 1925. Distinctive architectural features include the main entrance, which is a replica of an Egyptian temple in the valley of the Nile River. Wainscoting seven feet high around the main lobby is made from Tennessee marble. The temple was acquired by the city in 1945 after voters approved bonds for its purchase. It was named Memorial Auditorium to honor the servicemen of the city who took part in World Wars I and II. Through the years, many types of entertainers have been presented on the auditorium stage, including the Ziegfield Follies, Will Rogers, Vice Pres. Charles Curtis, Golden Gloves boxing tournaments, and political conventions. (Courtesy of Malcolm Turner.)

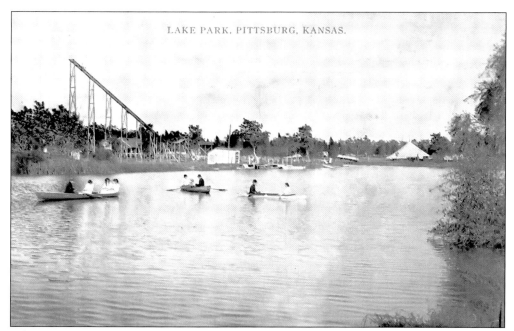

LAKE PARK, PITTSBURG, KANSAS.

When Pittsburg was 25 years old in 1901, Lakeside Park in the southwestern part of the city was already a popular entertainment center. The slides and buildings in the background of this photograph were located in the bend on the lake's north side. Boats and fishing tackle could be rented on a daily basis, and the record catch by 1901 was a seven-and-a-half-pound bass.

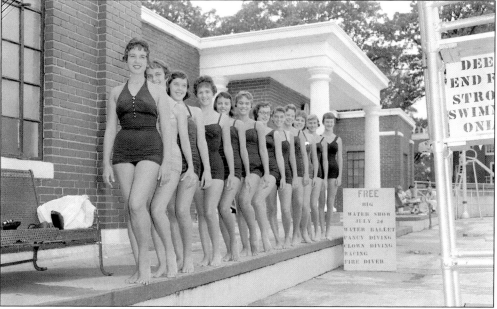

The Pittsburg Department of Parks and Recreation hosted its third annual water carnival on July 24, 1959. These 12 bathing beauties performed in the water ballet. From left to right, the ballerinas are Julie Macheers, Mary Stowers, Mary Ann Vietti, Sherry Elliott, Noberta Wachter, Barbara Dixon, Gloria Amershek, Waren Wilbert, Peggy McNally, Terre Kirk, Mimi Krusick, and Jan Trobridge.

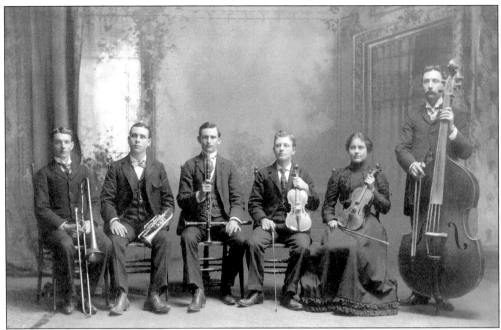

Frank S. Botefuhr came to Pittsburg in the summer of 1884 from Fort Smith, Arkansas. He offered private music lessons and took charge of the management of the Rhodes Opera House and later the LaBelle Theater. In 1886, Botefuhr opened his own store to sell musical instruments. He was particularly noted for offering two personal brands of pianos: the Frank S. Botefuhr Special and the Love Nest. This photograph of a Pittsburg dance orchestra was taken in the fall of 1898. The members from left to right are Arthur Williams, Mose Dobie, Bill Schreib, Frank Botefuhr, Nannie Wheeler, and John Swift.

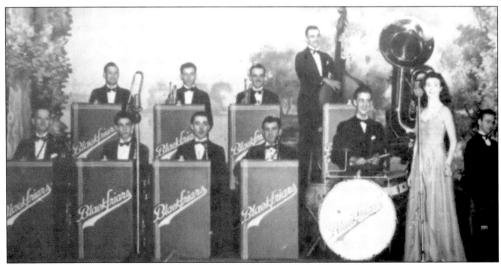

John Scalet, the owner and manager of the Pla-Mor tavern and pool hall after 1950, was also a musician who began his professional career with a local group known as the Blackfriars. This photograph was taken in 1941 when Scalet was manager of the group. He continued to perform with a group by this stage name into the 1970s.

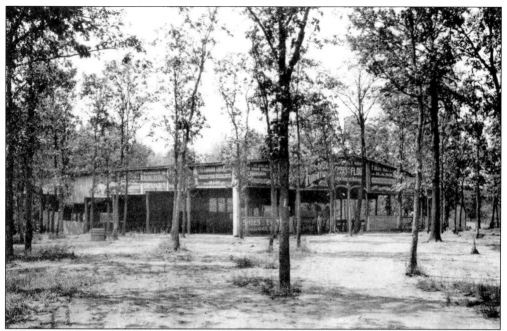

This photograph, taken in 1901, shows an open-air auditorium that once existed in Lincoln Park. The auditorium was originally constructed for reunions of the GAR before it sold the park to the city of Pittsburg. The wooden structure had a roof but no sides, and it sat near the site of the Lincoln Park auditorium that was constructed in 1911.

One of the earliest recreational centers for Pittsburg was Forest Park, located on West Fourth Street just south of the Hull and Dillon Packing House. A half-mile horse track was completed in Forest Park in 1889 that was also used for bicycle races between 1895 and 1900. W. W. Bell secured a lease on the park in 1901 and instituted an open-air theater that was well attended. Bell continued to operate the theater in Forest Park until 1903.

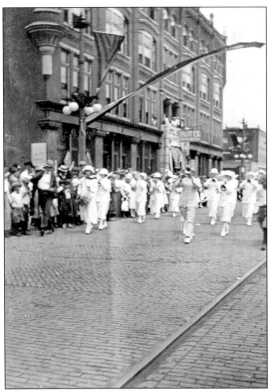

Prof. John Cantanzaro, a local music teacher, organized an all-girl band that performed frequently in Pittsburg. In this 1918 image, Cantanzaro, playing the trumpet, leads the band past the Hotel Stilwell in a parade celebrating the end of World War I.

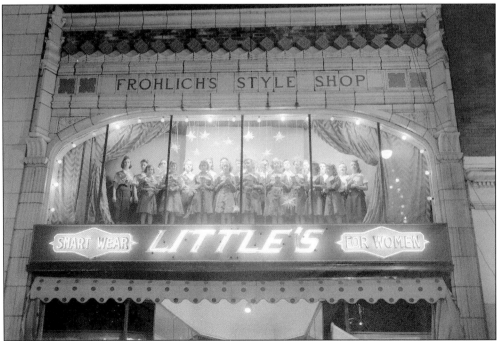

Local Girl Scouts perform Christmas carols from the second story of Little's in December 1957. Robert Lyerla, store manager of Little's, piped the music onto the street to entertain the passing Christmas shoppers.

The band dome in Lincoln Park is named for John J. Richards, a local musician who was instrumental in its construction in the 1930s. Richards taught music at Pittsburg High School and directed several local bands, including the Pittsburg Municipal Band. Earlier Richards traveled with several theatrical companies, played solo cornet for Barnum and Bailey's Circus, and was bandmaster for the Ringling Brothers Circus for 10 years. In this photograph of the Richards band dome taken about 1945, Walter McCray conducts the Pittsburg Municipal Band. McCray was chairman of the music department at Pittsburg State University from 1915 until 1947.

Early-day residents of Pittsburg were well acquainted with soapbox speakers. Evangelists, temperance lecturers, socialist politicians, and many other orators were regular fixtures of the community. In this April 1902 photograph, Anna Carter orates on the tree in history as part of an Arbor Day program conducted by the Pittsburg High School. Other students gave two-minute speeches on moonshine, sunshine, April showers, Kansas zephyrs, destructive animals, Pittsburg smoke and dirt, and leaves.

The men in this photograph were part of the Thursday Industrial Bowling League at the Bowl, located at Sixth and Locust Streets. The photograph was taken in October 1961. Over 10 leagues for men, women, mixed, and junior teams were hosted by the Bowl in 1961. Nearly an equal number were hosted by a second Pittsburg bowling alley known as Holiday Lanes that still exists. The Bowl was originally the Pittsburg Eagles Hall and is today home to a dance studio.

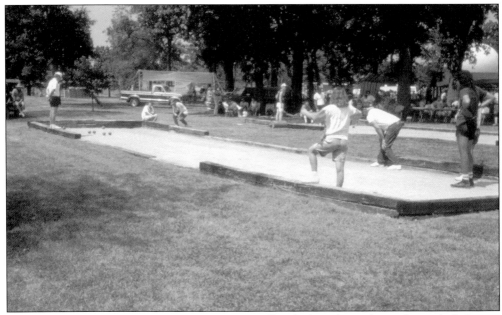

In Pittsburg's Lincoln Park, it is not uncommon still to find residents playing bocce ball. Bocce, an old game similar in some regards to bowling and shuffleboard, was introduced to the area by the numerous Italian immigrants to southeast Kansas in the early 1900s. Admirers of the game claim it dates back to 5200 BC. (Courtesy of William Powell.)

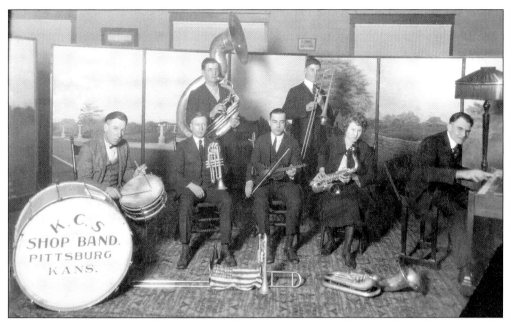

One of Pittsburg's many early bands was the Kansas City Southern Railway shop band. The mural behind the band members appears to be a painting of the entrance to Lincoln Park in Pittsburg. The park auditorium was completed in 1911, suggesting this photograph was taken sometime shortly after that date.

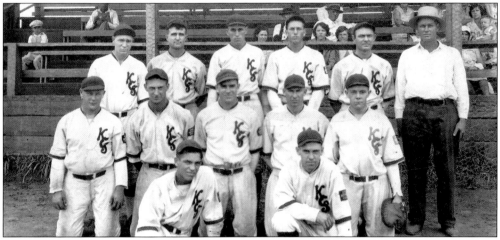

In this photograph, taken about 1929, a semiprofessional baseball team sponsored by the Kansas City Southern Railway features three famous Pittsburg athletes and coaches. Don Gutteridge played for the Boston Red Sox and then coached, managed, and scouted for the Chicago White Sox, Kansas City Royals, and Los Angeles Dodgers. His cousin Ray Mueller played 14 seasons in the majors with the Boston Braves, Pittsburg Pirates, Cincinnati Reds, St. Louis Cardinals, and New York Giants. Carnie Smith coached football at Pittsburg State University from 1949 to 1966 and won two National Association of Intercollegiate Athletics championships in 1957 and 1961. Pictured from left to right are (first row) Gutteridge and Crax Brady; (second row) Smith, Paul Fisher, Frank "Jip" Hill, Tom Engle, and Mueller; (third row) Ernie Dunbar, Finis Stipp, Chuck Huntington, W. Frank "Peanuts" Anderson, Harry Tavis, and Fred Puffenberger. (Courtesy of the Pittsburg Public Library.)

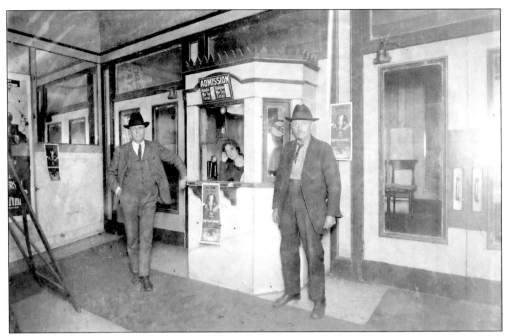

The Grand Theater was located at 307 North Broadway in a building constructed especially by Willard "Pap" Daly and Ira Clemens in 1914. The theater employed an orchestra for musical attractions and movies. The Fox Theater Corporation later operated the Grand Theater for many years, before the building was remodeled, for commercial use by the Jackson Electric Company. (Courtesy of the Crawford County Historical Museum.)

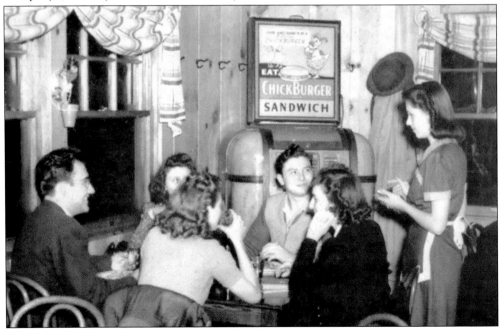

A "Coke date" at the Otto-Way drive-in, located at 1402 South Broadway, was a popular option for many years. The Otto-Way was located close to the college, and as this photograph from 1942 shows, the gang was always there.

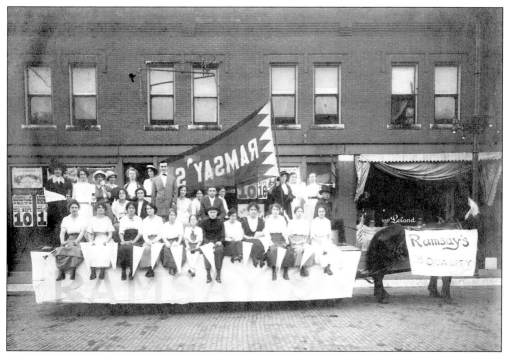

Ramsay's mercantile store employees participate in Pittsburg's Labor Day parade of 1914. They pause for this photograph in front of the New Leland Hotel on West Sixth Street. The posters in the background advertise the Hagenbeck-Wallace Circus that was scheduled to be in Pittsburg on Thursday, September 10.

It is well documented that bootleg alcohol was widely produced in southeast Kansas during Prohibition and also widely distributed throughout the United States and Canada. This photograph comes from the Prenk family collection and is believed to have been taken at the time Prohibition was repealed in 1933.

Over a span of 68 years, from 1912 to 1980, the winner of the annual high school football game between the Columbus Titans and the Pittsburg Purple Dragons was awarded this coal bucket as a traveling trophy. In the early years of the coal bucket game, Columbus held a slight edge in victories. Pittsburg began to show dominance after 1932, winning 24 games in the next 40 years and 8 of 9 games played from 1972 to 1980. This fearsome rivalry ended, in part, due to the size and classification difference in the two schools, but the rivalry was revived in 2007.

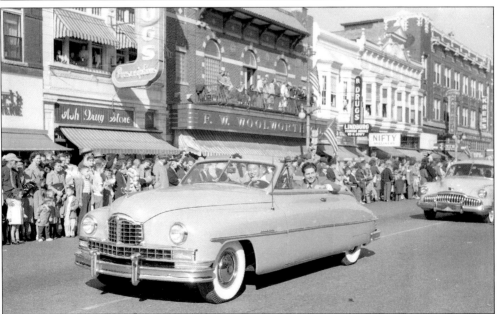

A Kansas State Teachers College homecoming crowd estimated at 14,000 lined Broadway in October 1949 to watch the traditional parade that took 90 minutes to pass by. Featured attractions included 24 bands and 60 floats. Milton Zacharias, a Wichita lawyer and president of the alumni association at the college, smiles at the crowd (seated right rear) as he rides along in this 1948 Packard.

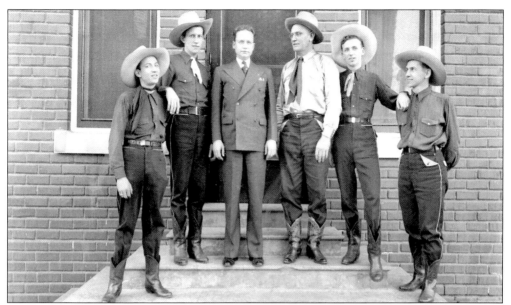

A. J. Cripe, third from the right, is joined by Kansas governor Payne Ratner, third from the left, and members of the musical group the Pals of the Prairie. Cripe was for many years one of Pittsburg's most colorful businessmen. He organized musical groups to advertise the A. J. Cripe Bakery over KOAM radio and to travel through the area performing at community functions. Cripe later used these same advertising techniques to be elected to the state senate from Crawford County. (Courtesy of the Crawford County Historical Museum.)

Ralph "Wild Red" Berry became widely known throughout the nation as a wrestler. As a youngster, Berry trained at the YMCA in Pittsburg. He eventually left his job as a blacksmith's helper at the Kansas City Southern Railway shops to pursue his wrestling career full time. Berry participated in the popular Texas rules style of wrestling and held world championships in two different weight categories.

One of Pittsburg's most accomplished entertainers and historians of American and African American folk music is Lemuel Sheppard. Originally from Kansas City, Sheppard earned a degree in music theory and composition from Pittsburg State University and has made Pittsburg his home since that time. Sheppard has performed in over 200 U.S. cities, including a performance at the Kennedy Center in 2000. A recent project was his composition and performance of the sound track to the award-winning documentary *Black/White and Brown* on the 50th anniversary of the *Brown v. Board of Education of Topeka* Supreme Court decision.

KRPS Radio, a National Public Radio affiliate, was established on the campus of Pittsburg State University in 1988. The Baxter Broadcasting Center, located in Shirk Hall, houses the radio station. The center is named for Frances B. Baxter who, with her husband E. V. Baxter, established the Pittsburg Broadcasting Company, KOAM Radio, and KOAM Television. In this photograph, Frank Baker, the first general manager of KRPS, stands in front of Shirk Hall.

Seven

A CIVICS LESSON

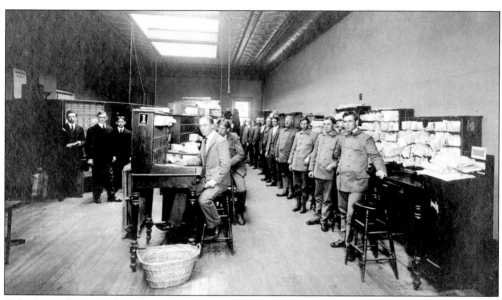

Orla Samuel Casad (standing fourth from right) was born in Illinois in 1846 and served in the Illinois infantry for three years during the Civil War. After graduation from McKendree College in Illinois, he passed the bar examination in 1876 and moved to Mesilla, New Mexico, to practice law and run a newspaper. He served as a government scout during the Victorio Apache Indian War in 1879 and 1880 and then moved to Kansas. Settling in Pittsburg in 1885, Casad taught school, practiced law, and engaged in the real estate and insurance businesses. He was appointed Pittsburg postmaster in 1890 and held that position for four years. In 1898, Casad became the first and only mounted letter carrier in Pittsburg, taking the mail to outlying districts of the city on horseback. Casad was a captain in the Kansas National Guard; held the positions of police judge, city clerk, and justice of the peace; was active in the Methodist Church, the Masonic lodge, and the Modern Woodmen of America; was a speaker for the Republican National Committee; and was commander of the Pittsburg post of the GAR. Casad and his fellow Pittsburg postal workers are seen in this photograph from about 1900.

In the fall of 1882, a company headed by S. H. Lanyon, the smelter owner, drilled a well on the northeast corner of Pine and Seventh Streets to prospect for natural gas. At a depth of 1,205 feet and at a cost of $3,300, they ended up with an artesian well they cared little about. By 1885, ownership passed into the hands of A. H. McCormick, who developed the waterworks. McCormick built a brick tower with a tank on top to develop pressure. To celebrate the grand opening, McCormick advertised that Mr. Gander would jump off the tower, some 60 feet high, for "the amusement of the audience." This attracted a large audience who witnessed McCormick toss a large goose, Mr. Gander, off the tower. This photograph of the waterworks was taken about 1904.

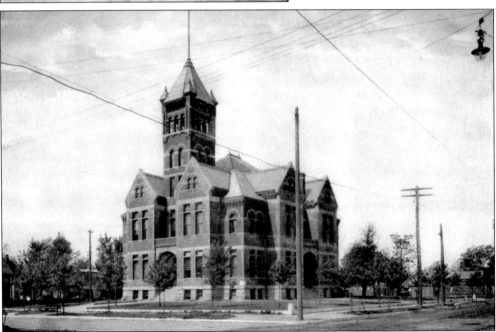

This Pittsburg city hall and courthouse building was completed in early 1901. It was one of the finest in the state of Kansas when completed. On February 8, 1901, the Kansas state legislature divided the Crawford County district court jurisdiction between the county seat of Girard and Pittsburg. The courthouse building in Pittsburg also served as a city library from 1902 to 1910.

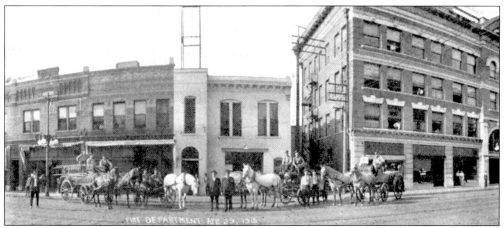

Pittsburg's first organized fire department appeared in 1898. Before that date, neighborhood bucket brigades were frequently called into action to extinguish roof fires during the period when coal was the primary heating fuel used in town. In modern times, fire station No. 1 has been located at Seventh and Pine Streets, but the earliest site was in the 100 block of West Fourth Street, seen in this photograph taken in 1914. Fire horses were still used to pull the equipment, and in June 1914, a popular fire horse named Deck was killed during the Russ Hall fire on the campus of Pittsburg State University.

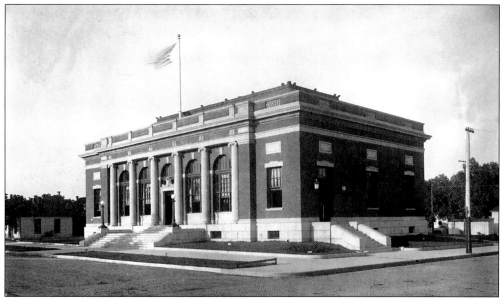

The first post office for the city of Pittsburg was located on the northwest corner of Broadway and Third Street from 1877 until 1894. It was moved to the southwest corner of Broadway and Seventh Street and later to 712 North Broadway. A new post office for Pittsburg was dedicated in July 1911. The photograph above was taken on July 1, 1911. In order to ensure a good downtown location for the post office, a group of Pittsburg citizens contributed sufficient money to purchase a lot on the northeast corner of Seventh and Locust Streets. In turn, they sold the lot to the federal government for $1. The building was enlarged in 1932 with an addition constructed on the east side.

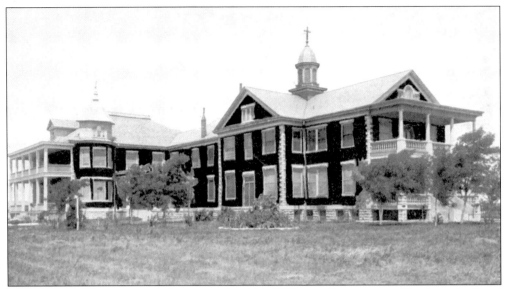

Mount Carmel Hospital was dedicated on April 14, 1903, on a 40-acre tract of land that bordered on the northern edge of Pittsburg and the southern edge of Frontenac. The original structure held 20 beds and was operated by the Catholic sisters. Patient rates ranged from $7.50 to $15 per day for those who had the means to pay. The destitute sick were cared for free of charge. A first addition was completed in April 1908, and in 1916, a two-story building, referred to as the Annex, was added. This image of the hospital reflects how it appeared in 1918. A final addition was completed in 1951.

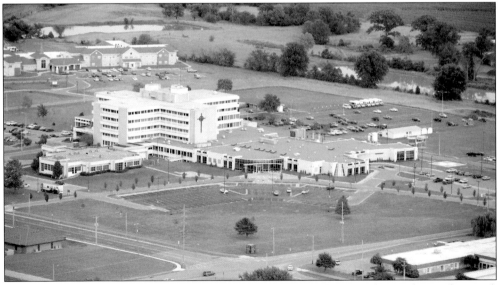

In the 1960s, plans to build an entirely new Mount Carmel Hospital were being discussed. Engineering tests on the original grounds recommended that new construction be avoided because the area had been undermined many years before by the deep-shaft coal miners. A 70-acre tract of land near the intersection of Centennial and Rouse Streets was purchased from the Norman Grotheer family for the site of a new Mount Carmel Hospital. Construction of the new facility began in 1968, and patients were transferred to the new hospital on May 19, 1971. This recent aerial photograph shows additions completed since 2003. (Courtesy of Malcolm Turner.)

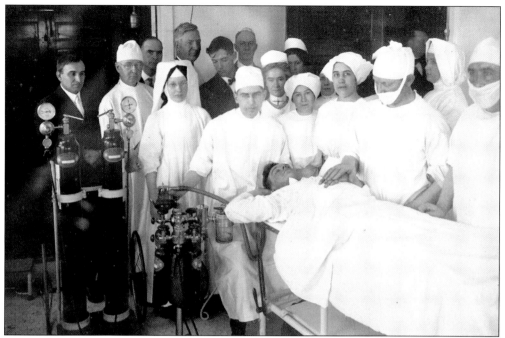

This photograph was taken inside the Mount Carmel Hospital that opened in April 1903. The image documents the very first surgical procedure performed in the new facility. (Courtesy of the Crawford County Historical Museum.)

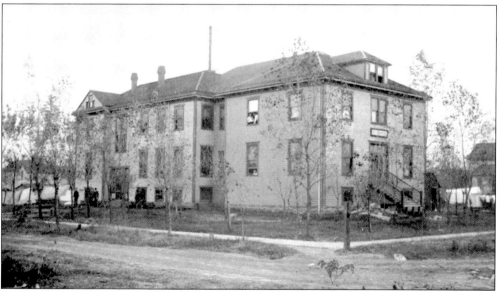

Dr. George W. Williams was instrumental in the founding of the City Hospital of Pittsburg in June 1894. Treatments were free; the only expense was for board and nursing if a stay was required. The facility began in Pittsburg's first school building that was constructed in 1877, and operational funds came from private capital. During the first year, about 150 patients received treatment, and the demand for services quickly outgrew the space available. In 1897, the city built the Samaritan Hospital seen in this 1901 photograph. This hospital was closed in 1912, a short time before the death of Williams.

In 1954, for the first time in its history, the Bureau of the Census in the United States Commerce Department assigned the processing of questionnaires for an agricultural census to a location outside the District of Columbia. Kansas senator Andrew F. Schoeppel seized the opportunity to establish one of the nation's two farm census operations in Kansas. An office was established in Pittsburg, and approximately 3.6 million questionnaires passed through the office. At its peak, over 700 employees worked in the facility seen in this photograph taken in 1959. The initial success led the census bureau to locate an age search branch in Pittsburg that was responsible for the maintenance and research of 739 million files.

Philip Henry Callery sits at his desk in the Pittsburg law firm of Callery and Callery around 1916. He was admitted to the bar of the supreme court of Kansas and then to the bar of the Supreme Court of the United States. In 1915, Philip, with his wife, Ida Hayman Callery, opened the law firm of Callery and Callery in Pittsburg, where they became the lawyers of Alexander Howat and District 14 of the United Mine Workers of America. Philip was also a leading orator and lyceum lecturer for the Socialist Party. Ida died in 1917. James Callery joined the firm in the late 1920s, and the firm continued to practice until 1944.

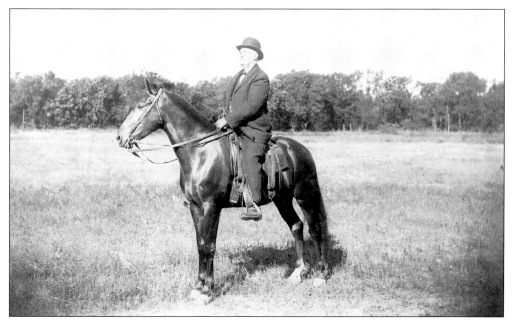

Morris Cliggitt, a classmate of William Jennings Bryan at the Union College of Law in Chicago, became mayor of Pittsburg, city attorney, one of the founders of the Pittsburg Public Library, and a United States district attorney for Kansas. Cliggitt was active in the Democratic Party at the local, state, and national levels. He was also one of the major stockholders in the Pittsburg, Frontenac and Suburban Electric Railway Company and served as its president in 1898.

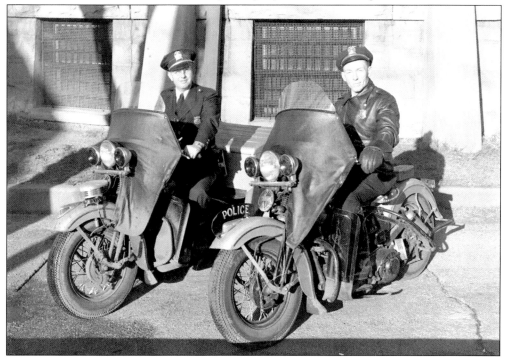

This photograph shows Pittsburg city police officers Don Hearn (left) and John Chester (right) in 1948.

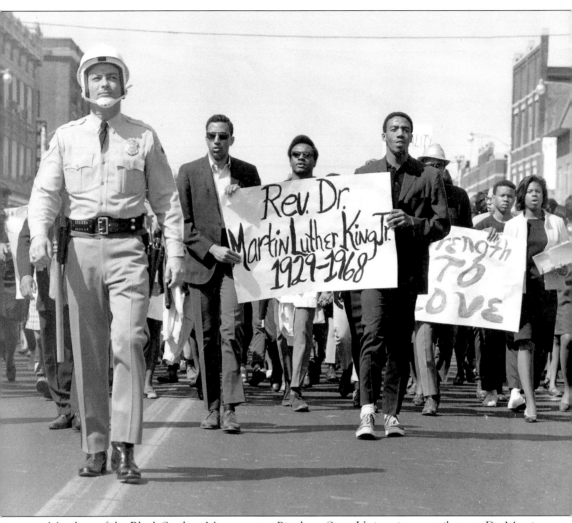

Members of the Black Student Movement at Pittsburg State University pay tribute to Dr. Martin Luther King Jr., on April 9, 1968, by organizing a memorial march in downtown Pittsburg. Afternoon classes at the university were dismissed, and approximately 200 students, faculty members, and community residents were escorted down Broadway by city police and Kansas highway patrol officers.

Eight

THE TIES THAT BIND

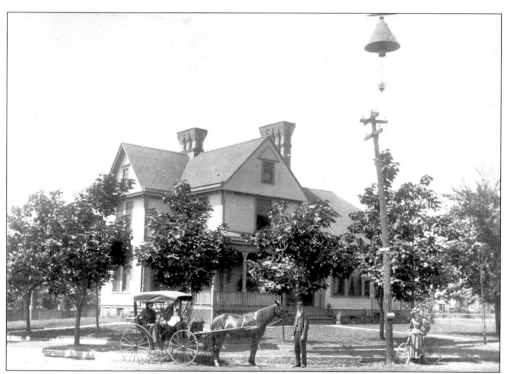

In 1880, this home at 401 West Euclid Avenue was built by Franklin Playter, the founder of Pittsburg. Playter lived in the home until 1892 when he moved into the Hotel Stilwell. At the time this photograph was taken in 1896 or 1898, the house was owned by Julius Greef. The occupants of the carriage are identified as, from left to right, Otto, Bella, and Dorothy Greef. Julius is standing by the horse, and Anna Mahlese is holding the bicycle. John Albert Gibson, president of the Standard Ice and Fuel Company, purchased the property in the summer of 1913, and members of the Gibson family occupied the house until 1980. (Courtesy of Linda and J. T. Knoll.)

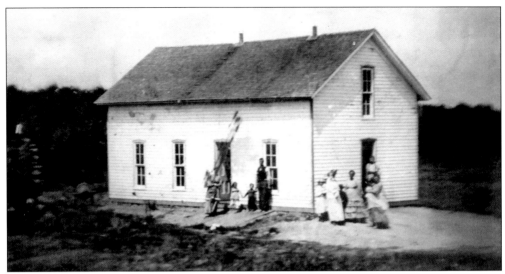

George Hobson, a Civil War veteran from Iowa, settled within the present-day city limits of Pittsburg with his family in 1865. Hobson resided on the banks of Cow Creek in what is today the Random Acres subdivision. After five years of living in a log cabin, George and Mary Hobson built this two-story house that also served as a post office, general store, and blacksmith shop. The original log cabin is slightly visible on the left of this 1871 image. The settlement, known as Iowa City, ceased to exist shortly after Pittsburg was established. The Hobson family cemetery was located on their homestead of 160 acres and exists today as part of the Highland Park Cemetery.

This Wichita fair exhibit, from 1914, features a variety of products based on the coal, clay, agricultural, and educational resources in and around Pittsburg. On the right are products produced by students from the SMTN, now Pittsburg State University. Central to the exhibit are the coal mines and the clay products from the W. S. Dickey, Clay Manufacturing Company, that was located in Pittsburg after 1899. May Simons in 1911 wrote, "Beside the wheat field throbs the engine of a mining shaft and the shacks of French and Italian miners, who have not yet learned the English language, are grouped near the farm houses of some American who settled on government land forty years ago . . . it is this combination of the rural and the industrial . . . that creates the unusual condition in the region."

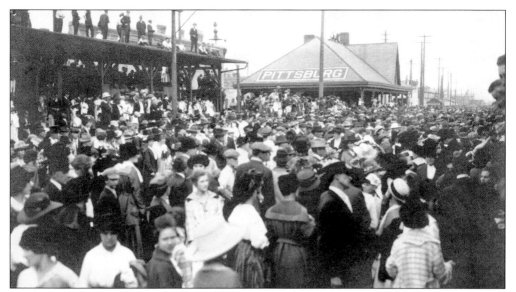

Pittsburg residents gather at the Frisco depot on October 1, 1917, to watch local soldiers board transport trains bound for Fort Sill, Oklahoma. Nearly 15,000 citizens crowded the station platform, filled the railway yard, and spilled onto nearby streets. The soldiers, members of locally raised Batteries C and D of the 130th Field Artillery, carried their gear in "suitcases," which were flour sacks with drawstrings that were presented to them by members of the Pittsburg Federation of Women's Clubs. Nearly 1,500 sandwiches were prepared for the men at the First Methodist Church, and another large quantity of food was prepared in the college cafeteria.

This photograph documents the last time the firing squad of the U.S. Military Veterans, Camp 38, was assembled. The image was taken on May 30, 1959, in Mount Olive Cemetery. From left to right, the men present are William Arvin, R. C. Brown, Charles Ferris, Charles Ritter, W. O. Junkerman, Bert Gilbert, and John Campbell.

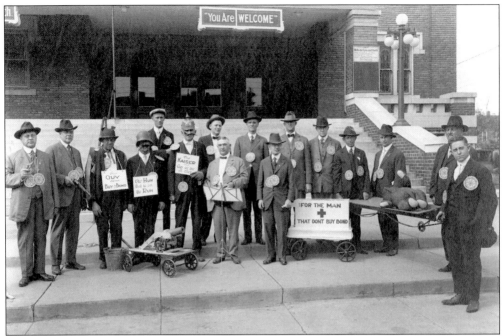

Members of the Pittsburg Rotary Club assemble on the steps of the First Methodist Episcopal Church on July 4, 1917, to promote the purchase of war bonds. Patriotism abounded later in the day as the club joined hundreds of other participants in a lengthy parade through downtown Pittsburg.

A group of students from the college publicly express their opinions about the Vietnam conflict when they assemble in April 1970. Earlier, in November 1969, the National War Moratorium movement attracted about 100 persons to gather for a peaceful demonstration on the campus.

This photograph of Sol Hester was taken in 1947. He was, for many years, janitor at the Douglas School at 306 West Eleventh Street. Douglas School was operated for black children from 1913 until 1950 when the public schools of Pittsburg were fully integrated. Hester first came to Pittsburg in 1899 from Alabama when the coal companies brought hundreds of black miners into the Kansas coalfields to replace the members of the United Mine Workers who were on strike.

Here is the entrance to the popular Lincoln Park as it appeared in 1918. The construction of the large pavilion began in August 1910 and was dedicated 12 months later. Credit for the design of the auditorium and the park's paths and plantings is attributed to George Edward Kessler, then considered the world's best landscape architect. Kessler designed the park and street systems of Kansas City and Central Park in New York, among hundreds of other projects. In the 1950s, this auditorium was encased in wood, and the roof was reshaped to a French mansard style. The classical columns were removed, but the basic outlines of Kessler's paths and plantings remain as beautiful as they were almost a century ago.

Walter McCray, chairman of the music department (left), and William Aaron Brandenburg, president of the Kansas State Teachers College (center), are pictured with John Philip Sousa (right) at the Missouri Pacific Railroad station in October 1927. A large crowd greeted the "March King," who was visiting Pittsburg for the third time. Sousa, upon the invitation of McCray, came to conduct five area high school bands in a matinee and evening performance in the Carney Hall auditorium on the Pittsburg campus.

Attorney A. Staneart Graham designed and constructed one of the most distinctive houses in Pittsburg in 1934. The walls are made of rock assembled inside wooden forms and covered with concrete. The concrete vaults of the lower roof are reinforced by iron rails salvaged from the Joplin and Pittsburg Railway Company. The house features a number of energy-saving devices such as a double roof, deep overhanging eaves, and a solar water-heating system.

Members of the Caldwell family pose at their home on West Forest Avenue in 1913. William W. Caldwell worked for the Nesch Brick Company and the W. S. Dickey, Clay Manufacturing Company before forming W. W. Caldwell and Sons Contractors. He was the founder of the first National Association for the Advancement of Colored People (NAACP) chapter in Crawford County and founded the first Black American Democratic Party organization in the county in 1930. This organization sponsored some of the largest Emancipation Day celebrations in the state of Kansas and brought such luminaries as Jackie Robinson to Pittsburg. During the big band era, the Caldwell home was visited by Chick Webb, Ella Fitzgerald, Count Basie, and numerous other performers.

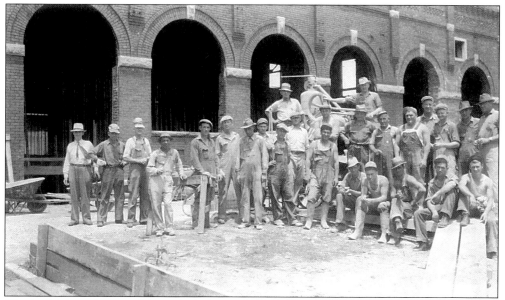

Charles Mishmash, second from the left, was the foreman of this Work Projects Administration construction crew in the 1930s. Work was progressing on the construction of Hutchinson stadium and field at the Pittsburg High School and is seen in the background of this photograph. (Courtesy of Brenda and Robert Mishmash.)

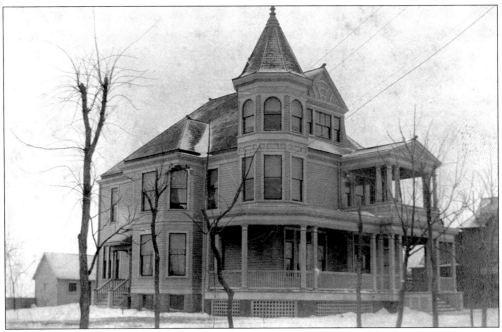

John R. Lindburg built this house at 507 West Euclid Avenue two years before this photograph was taken in 1895. Lindburg organized the First National Bank, and he later became president of the Pittsburg Building and Loan Association. The home stayed in the Lindburg family until 1946.

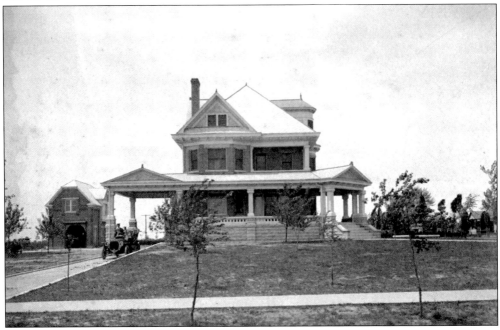

One of the most stately homes in old Pittsburg was the Con A. Miller home on South College Avenue. Miller moved to Pittsburg in 1878 and entered the mercantile business with H. C. Willard. In 1890, Miller entered the real estate business with James B. Smith. The firm of Smith and Miller developed much of the present-day southwestern residential portion of Pittsburg.

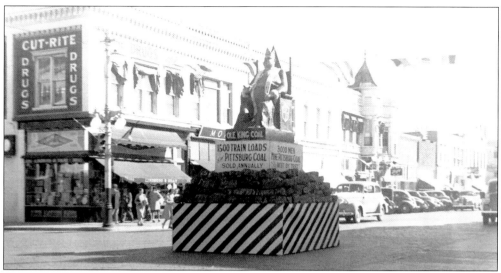

A King Coal festival was held in Pittsburg each October from 1934 to 1940. An estimated 25,000 people participated in the first festival that was designed to lift the spirits of all the people of southeast Kansas who were suffering economically during the Depression. The statue of King Coal stood throughout the week of the festivals at the intersection of Broadway and Fourth Street. The governor of Kansas came each year after 1934 to crown the coal queen, and the size of the crowds increased to over 40,000. Despite the festival's popularity, the planning committee sensed long before December 1941 that America would be at war in Europe and made no plans for an eighth festival.

The present-day Little Balkans Festival, inaugurated in 1984, drew its inspiration from the King Coal festivals of the 1930s. Each Labor Day weekend, thousands attend the Little Balkans Festival that celebrates the region's history and ethnic diversity. (Courtesy of William Powell.)

Reflections of the ethnic heritage of Pittsburg can be seen in many ways. This advertisement for dog food sold by Grimaldi's Cash Grain and Feed Company is well remembered by the older residents of Pittsburg. (Courtesy of William Powell.)

Nothing brings the Pittsburg community together faster than a good football game. Pittsburg State University students and fans cheer on the Gorillas during the Family Day game against Emporia State University in 2005.

The first Pittsburg Kiwanis Club was chartered on March 3, 1921. It is the fifth-oldest club in the state of Kansas. In 1949, the Pittsburg club began its annual Pancake Day, to raise funds for youth programs and scholarships, a traditional event that still occurs. This photograph shows the 1957 Pancake Day held in Pittsburg's Memorial Auditorium.

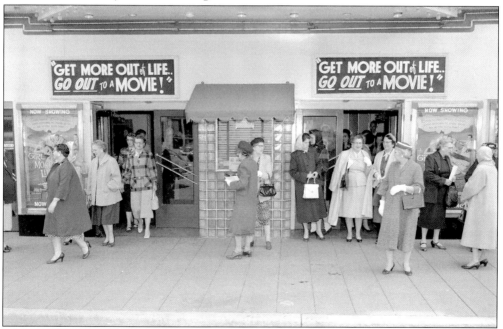

The Crawford County Cancer Unit invited all women of Crawford County to attend a free movie at the Midland Theater in Pittsburg on April 30, 1958. Although the movie the Midland was advertising was *The Girl Most Likely* with Jane Powell and Cliff Robertson, the educational feature these ladies watched was titled *Self Breast Examination*.

This old miner's house was moved to Second Street and Broadway in 1976 as Pittsburg celebrated its centennial and the nation's bicentennial. The old house, a square, four-room structure of wood, was built by the Santa Fe Mining Company in 1906. It was used as headquarters for the Pittsburg Centennial/U.S. Bicentennial Committee through the year's events.

Kansas governor Kathleen Sebelius and other dignitaries were in Pittsburg in July 2008 to dedicate the new community pavilion and miner's memorial. A map of the southeast Kansas coalfield carved on granite and additional stones containing the names of coal miners are one feature of the Immigrant Park facility. (Courtesy of Malcolm Turner.)

Debra Barnes, Miss America 1968, greets the homecoming crowd shortly after winning the crown. Barnes, from Moran, was a sophomore at Pittsburg State University when she won the title of Miss America.

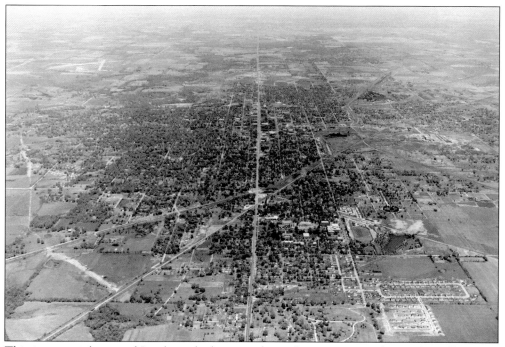

This is an aerial view of Pittsburg, looking north, as the city appeared in 1951. Still evident are the north–south orientation of the original downtown district and the influence of the railroad connections.

DISCOVER THOUSANDS OF LOCAL HISTORY BOOKS
FEATURING MILLIONS OF VINTAGE IMAGES

Arcadia Publishing, the leading local history publisher in the United States, is committed to making history accessible and meaningful through publishing books that celebrate and preserve the heritage of America's people and places.

Find more books like this at
www.arcadiapublishing.com

Search for your hometown history, your old stomping grounds, and even your favorite sports team.

Consistent with our mission to preserve history on a local level, this book was printed in South Carolina on American-made paper and manufactured entirely in the United States. Products carrying the accredited Forest Stewardship Council (FSC) label are printed on 100 percent FSC-certified paper.

MADE IN THE